John Milner

Rodchenko

DESIGN

Antique Collectors' Club

Design Series format by Brian Webb

Design: Rodchenko © 2009 John Milner

World copyright reserved

ISBN 978-1-85149-591-7

British Library Cataloguing-in-Publication Data
A catalogue record for this book is available from the British Library.

Antique Collectors' Club
www.antiquecollectorsclub.com

Sandy Lane, Old Martlesham
Wodbridge, Suffolk IP12 4SD, UK
Tel: 01394 389950 Fax: 01394 389999
Email: info@antique-acc.com
or
ACC Distribution
6 West 18th Street, 4th Floor
New York, NY 10011, USA
Tel: (800) 252 5231
Email: sales@antiquecc.com

Published in England by the Antique Collectors' Club Ltd.,
Woodbridge, Suffolk
Printed and bound in the United Kingdom

Frontispiece: Advertising bookmark 1924. Gouache on card, 13.5 x 13 cm. The text reads, 'Look'.
MERRILL C. BERMAN COLLECTION, NEW YORK

p.96: A. RODCHENKO AND V. STEPANOVA ARCHIVE, MOSCOW

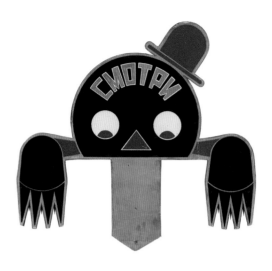

Acknowledgements

Without the magnificent assistance of Alexander Lavrentiev, the
Alexander Rodchenko and Varvara Stepanova Archive, as well as the
Museum of Private Collections, in Moscow, this book could not
have been made. They remain the indispensable sources of
knowledge about Rodchenko and his work. Without assistance and
illustrations from other collections it could not have been so wide
in its range, so diverse or so colourful. The intention to illustrate
less familiar works, which has been amplified through the
expertise and assistance of the Merrill C. Berman Collection, has
been decisive and greatly appreciated. I am indebted to the David
King Archive in London for my introduction to its astonishing
diversity and importance. The Ludwig Collection in Cologne has
generously provided images from its extensive holdings of Russian
art. Finally, emphatic gratitude is due to the immensely helpful
director and curators at the Museum of Contemporary Art, The
Costakis Collection, at Thessaloniki, itself a major centre for
research in Russian art, as Maria Kokkori, who has worked there,
can confirm.

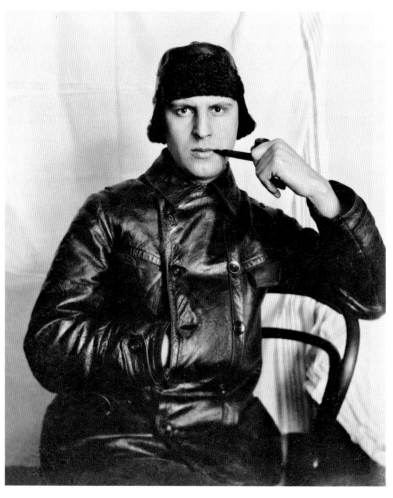

Portrait of Alexander Rodchenko 1916-17
Photograph.
A. RODCHENKO AND V. STEPANOVA ARCHIVE, MOSCOW

Design
Rodchenko

*For Rodchenko design arose out of painting, but opportunity and politics made him
an extraordinary painter and an extraordinary designer. His range spanned from
furniture to fabrics, stage and film design to ceramics, posters, books, architectural
projects, propaganda, exhibition display, and radical innovations in photography. He
was a central figure in Russian Constructivism, a radical activist, a pioneer of
photomontage, a theorist, and a teacher. He was an active force in the organization of
the first museums of modern art that arose in Russia in the first years after the
Russian Revolution of 1917.*

Rodchenko grew up in Kazan, east of Moscow, in a family associated
with the theatre and theatre props. Alexander Rodchenko attended
art school in Kazan, and his earliest works included designs for
Oscar Wilde's play *Salome*. Rodchenko made these designs in an
elegant but awkward Art Nouveau style, showing his awareness of
pattern and stylization. In Russia the involvement of painters with
theatre had a long history. It was an essential feature of the lives of
many Russian artists. In the twentieth century, for example,
Rodchenko, Popova, Tatlin, Malevich, Stepanova, and many others,
all worked on or for the stage. The theatre provided opportunities,
showed the painter an audience, demanded imagination on a grand
scale, and it allowed for experiments with effects of coloured
lighting. It had much to offer compared with and in addition to
exhibitions and private commissions. The illuminated, dynamic
stage could be for the painter an equivalent to picture-space, only
bigger, deeper, and active instead of passive. What might at first look
like a painting – for example, a forest painted by Tatlin on card or
board – might at the same time be a stage design. Rodchenko was
one generation younger than the sailor and painter Vladimir Tatlin,
but the theatre was also in Rodchenko's background from the start.

In 1914 Rodchenko was alerted to the most radical of Russian art movements. That year Russian Futurists performed in Kazan, and Rodchenko saw their leading figures in action. Led by the painter-poet David Burliuk, accompanied by the Futurist pilot and poet Vasili Kamensky, and by the brilliant young revolutionary poet Vladimir Mayakovsky, they lectured, disputed, and accosted their audiences with bizarre declarations of new art, throwing off the great national literary figures, Alexander Pushkin, Leo Tolstoy and Fedor Dostoevsky, from the 'steamer of modernity'. In an absurd parody of Oscar Wilde's elegance, Burliuk wore a top hat, dress jacket with waistcoat, sometimes with vibrant, broad stripes, one earring, and had a small dog painted on his face. Kamensky performed with an aeroplane painted on his face. The young Mayakovsky dressed with equal elegance, in his celebrated yellow and black wide-striped waistcoat. These performances systematically extended to absurdity the dandyism of the 1890s, and these Futurists wore peasants' red wooden spoons in their top pockets.

The Futurists' lectures demonstrated their three main themes. New art in Russia was contrasted with the work of Cubist painters in Paris, and with Italian Futurists. These performers demanded recognition for the Russian Futurists, the *Budetlyane* or future-dwellers. This contrasted sharply with the urban, mechanistic, and dynamic vision promoted by the poet F.T. Marinetti, the leader of Italian Futurism. Instead of thrilling to the roar of a motorcar engine, as Marinetti did, the Russian Futurists studied the structure of language extended through time and space. They created Futurist images of the peasant, in contrast to the Italians' speeding modernity. Russian Futurists made books out of wallpaper, using cheap printing techniques, and they gave their books absurd names, of which Kamensky's *Tango with Cows*, is an example. Thirdly, they promoted *Zaum*; an invented name, derived from the Russian *Za* (beyond) + *Um* (mind, intelligence), for a new sound language 'beyond sense'. *Zaum*, devised by the Russian Futurist poets Velimir Khlebnikov and Alexei Kruchenykh, drew in painters at once. The painter Kazimir Malevich referred to some of his own canvases of

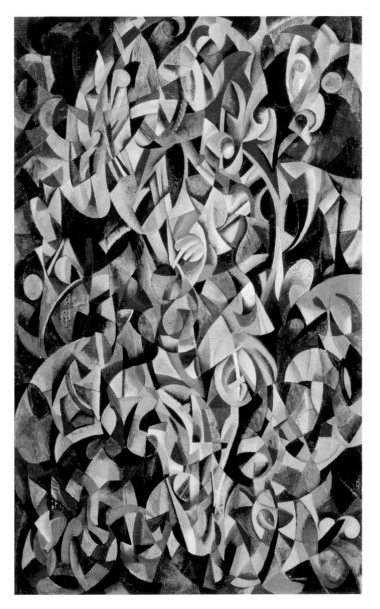

Dancer 1915. Oil on canvas, 144 × 91 cm. Signed and dated lower right, 'R 15'.
A. RODCHENKO AND V. STEPANOVA ARCHIVE, MOSCOW

1913 as *Zaum Realism*. The same year Malevich and the composer-painter Mikhail Matiushin, together with poets Khlebnikov and Kruchenykh, had staged the world's first Futurist opera, *Victory over the Sun*, at the Luna Park Theatre in St. Petersburg.

Thanks to the Futurist Tour that reached Kazan in 1914, the young Rodchenko was suddenly exposed to these bizarre but impressive innovations. It transformed his vision. He was still working with Futurists and their ideas twenty-five years later. New styles of performance, theatre, poetry, and art erupted before him, and he was quick to respond (p.7). He painted a large and dynamic *Dancer* assembled from a mass of colourful curved forms that animated the surface in an impression of movement and light and shade, in the process revealing the figure. There are black and white drawings too by Rodchenko, in which the image of a head and shoulders are constructed from curves and lines that recall the tight arcs of Russian Orthodox icon painting. At the same time he made paintings and drawings with intersecting planes and inconsistent lighting like a Parisian Cubist, so that the effect is half icon, half Picasso. Rodchenko was seeking a balance between Russian art and the West, raising issues of identity, inspiration, influence, and independence. These are the first signs of Rodchenko constructing the image from the predetermined elements of circular curves and straight lines.

He moved to Moscow where he met the painters Malevich and Tatlin whose competitiveness was leading them into public disputes and even fist fights. Both exhibited their most innovative and influential work in Petrograd and in Moscow in 1915. By that time Europe was plunged into war. Russian artists rushed home from their cultural travels in Western Europe – especially Paris, Berlin, and Munich – and all that they had seen, learnt and heard they took back with them to Russia. Thrown back together in Moscow and in Petrograd, at a time of national crisis, they debated, painted, constructed, and exhibited in an intense but isolated concentration of creative activity.

To many, the war presaged an apocalyptic era. The radical
innovations of Tatlin's *Corner-relief* constructions and Malevich's *Black
Square* were exhibited at 0,10: *The Last Futurist Exhibition* in Petrograd in
1915. They conjured up the broken machinery of warfare and the
semaphore of military communications. Strung across corner
spaces at the exhibition, they recalled to Russian viewers the sacred
corner space reserved for icons in the home. In that context they
could well have marked the decay of traditional values and beliefs
in religion as in art, or signalled dissatisfaction, dismay and dissent
stalking the streets of the great Russian cities as disastrous war
news percolated the public consciousness. Malevich's *Black Square*
could signify the painting out of religious belief, the black flag of
the anarchists blotting out the Saviour's face. Malevich called it 'the
zero of form', a painting to end the old conventions, although he
also called it a 'living royal infant', as if to indicate that the King is
dead, Long live the King, a dangerous gesture in the war years
under the last Tsar.

Cultural innovation thrived in this hotbed of radical dissent.
Inspired by both Malevich and Tatlin, Rodchenko developed a kind
of drawing and painting using a compass and ruler to diminish
signs of personal style and self-expression. He also deleted imagery
from these works, and the whole process of representing the seen
world. Using first black and white – and later colour – he began to
make compositions using only straight lines and circular curves to
create effects of transparency and movement. These graphic works
have a powerful rhythmic and visual impact but carry no image
beyond their own appearance. Between Tatlin's material
constructions on the one hand, and Malevich's dynamic geometric
paintings on the other, Rodchenko has established his own position
using precise instruments to create intricate pictorial compositions
that eliminated light and shade, colour, and texture. They appear
lively but are reductive and minimal, using only contrasts of black
against white to create a visual brilliance. Rodchenko had defined
his basic elements, though their effect was softened in 1915-16
when colour and shading return. In these gouaches a central knot

of forms is isolated against a background. The viewer seeks familiar images among these fragments but they cannot be identified. There are signs of light and shade, of flat and of curving surfaces, and some areas are varnished to provide effects of transparency and reflection. Even the titles have become systematic in his determination to avoid attribution of recognisable imagery to his paintings. These he called *bespredmetny* meaning 'subjectless' in Russian (confusingly translated into English as 'non-objective'). This implied a systematic rejection of the recognisable image, for a conscious manipulation of material and geometric elements.

In Rodchenko's non-objective paintings intersecting planes and transparent surfaces are assembled into compositions without subject – though they do suggest arches, struts, openings and spaces associated with architectural forms. Rodchenko's art refuses to reflect the observed world in any conventional way, but he is not making a decorative system either. He presents instead an assemblage of planes and lines hinting at illusions of space and construction. This is made as impersonal as possible with little sign of the painter's individual touch, although an emphasis on *faktura*, the revelation of material qualities, is evident.

A poster for a 1917 exhibition of Rodchenko's works of 1910-17 shows a dynamic and colourful use of lettering, derived in part from Russian Futurism. Letters tip and spill across the paper with a vitality of their own. This is a characteristic of pre-War Russian Futurist books and was announced in their *Declaration of the Letter as Such* in 1913, asserting that a letter's meaning is different when it is handwritten, block printed, or in different sizes. In Russia Futurist poets and painters liberated lettering from the typographic discipline of horizontal lines and consistency. Malevich and his followers, Ivan Puni and El Lissitzky, made poetic and extraordinary use of letter-forms in their exhibitions, posters, and graphic design, ultimately feeding the dynamics of Russian Futurist invention into experimental graphic design across Europe. Rodchenko, whose creative career was diverted by the Russian

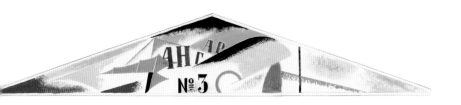

Futurists, retained his interest and excitement in the use of lettering
and words. A project to paint the triangular wall over the doors of
aircraft hangars shows Rodchenko's flair. The designs are fresh and
colourful but their lit, shaded and curving forms suggest aeroplane
flight. The lettering in *Hangar no.* 3 seems to hang in front of the wall.
The design for *Hangar no.* 7 incorporates the name of the French
flying pioneer and aircraft manufacturer Henry Farman, from whom
Louis Blériot acquired aeroplanes – as did the Russian Futurist pilot
and poet Vasili Kamensky, on Blériot's advice. From these early works
onwards Rodchenko extended the discoveries that he made in
painting and applied them to design projects. Painting into design
was an avenue that he was already eager to explore by 1917.

In that year Rodchenko was asked to design lamps for the Café
Pittoresque in Mosocw, a lively space in which artists, intellectuals,
and their public could meet . The lamp designs may have affected the
development of Rodchenko's painting. He worked on the project with
Tatlin and with the painter Georgy Yakulov. Rodchenko's drawings on
paper show how curved intersecting surfaces, perhaps made out of
reflective metal, would disperse the coloured light within the Café
Pittoresque (pp.13, 41). Features of the lamp designs and their colour
effects appear in contemporary paintings. This extraordinary synthesis
of utilitarian object and geometric painting shows how far
Rodchenko has moved away from self-expression. This is not so
much a painting of a lamp, as a painting for a lamp, or from a lamp.

This led Rodchenko to clarify the elements of his compositions. The series of paintings *Movement of Projected Planes* may depict visual effects from lamps, but here they have flat constructed planes with the inconsistent light sources possible only in paintings.

Rodchenko began making three-dimensional constructions of inter-slotted card in the same year for a series that he called *Assembled and Disassembled*. In addition, he worked on extraordinary collages made from found printed card or paper. These distinct pieces of the collage describe structures close to the free-standing constructions of the series *Assembled and Disassembled*, even though they are printed with bold imagery and lettering that distract the viewer looking for the structure. As the three-dimensional constructions in the *Assembled and Disassembled* series respond to gravity they require structural stability, a base and so on, unnecessary in the collages. This reveals, in a new way, Rodchenko's position between Malevich's illusion of weightless space and Tatlin's heavy material constructions. Rodchenko's paintings occupy the middle ground. In *Composition no. 71* a structural element, functioning visually like a spine or neck, leads down to the equivalent of a torso or base. This produces the impression of a robotic figure, the appearance of a geometric creature or automaton.

The intersecting planes of the paintings are only painted, but three-dimensional constructions by Rodchenko address actual issues of physical structure, gravity, materials, and rigidity: a territory between speculative painting and premeditated design. When Malevich exhibited *White on White* paintings in 1918, Rodchenko responded with black paintings in which texture, material, and *faktura* enliven the black surfaces. *Composition 71* is all black, almost a metre high, and painted in oil on canvas; within the depth of its dark tones, shimmering effects reveal curved planes repeating or intersecting against a less visible circular surface shape. Rodchenko's riposte to Malevich was a rejection of his illusion of limitless space and pure white spirituality. Rodchenko's emphasis was firmly fixed on geometric structures and physical substance.

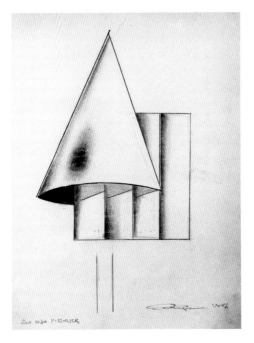

Light fixture design for Café Pittoresque, Moscow 1917
Black and red pencil on paper, 26.5 × 20.5 cm. Signed
and dated lower right, 'Rodchenko 1917'. Inscribed
lower left, 'For the Café Pittoresque'.
A. RODCHENKO AND V. STEPANOVA ARCHIVE, MOSCOW

The passage of one disc in front of another may suggest an eclipse
or transit of a planet before the sun, and an eclipse was visible in
Russia in 1918. The discs might recall the overlapping haloes of the
Virgin and Child in an Orthodox Christian icon of the Virgin of
Tenderness. In a series of paintings by Rodchenko they demonstrate
a geometrical relationship (p.17). He added materials to the paint
to assert its physical structure too. In these strictly symmetrical
compositions there is scarcely any opportunity for irregularity or
narrative. Yet these minimal compositions are no less powerful for
their elemental severity. These geometric relationships derive from the

study of the circle and the square, an ancient study inherent in every building that has a dome above a square base. Its harmonic ratios and proportional systems can be used in architecture, sculpture, painting and design. In Renaissance times and earlier it was used in diagrams of man's place in the Cosmos. Leonardo da Vinci's *Universal Man* is an example, his arms and legs stretched out to fit the circle and the square. In the revolutionary years following 1917, Rodchenko too used ruler and compass as instruments to work with the proportions of the square and circle. By 1918 he had made his minimal and consciously determined compositions into a focus for fundamental creative experiment.

As the new political regime began to restructure the visual arts, Rodchenko was there among the activists – in the new Museum Bureau, in the restructured art schools, in State Exhibitions, and in the debates at The Institute of Artistic Culture (Inkhuk). Here his search for a new impersonal and constructive culture fitted well with current thinking. The first director of Inkhuk, the painter Vasili Kandinsky, was criticized for his lack of materialism, despite his shift of thinking from the spiritual to the psychological impact of colour and form.

Kandinsky's view represented only one of the competing theories about the role of creativity in the new society. There was a powerful argument that Communist culture must arise from the workers and peasants in the Dictatorship of the Proletariat. This organization of Proletarian culture, Proletkult for short, attracted talented and radical creative people, including Sergei Eisenstein, who staged plays in factories, and whose early films were made without trained actors.

Others argued that the new culture must be completely classless, a new culture without the class implications of the past, where patronage had been ecclesiastical, Imperial, or mercantile. In any case, the power of churches, palaces and commercial galleries was now all gone, and the Soviet State was now effectively the only patron. The re-examination of art – its nature, purpose, and function – was inevitable and urgent.

Rodchenko's solution appeared, at least initially, to offer little scope to those who sought a proletarian culture. As geometry has no style, class, size, material or financial status, Rodchenko appeared naturally at home among those who sought creativity beyond social class. His radical paintings, built from basic elements, proposed a new understanding of a constructed, rather than a tastefully composed, culture. This had advantages. Firstly, its geometry could provide new perspectives on man's place in the order of things, and secondly the term 'constructive' could apply as readily to building and engineering as it did to painting. This could in turn imply the construction of the new society.

Karl Marx had concluded his Communist Manifesto with the call, 'Workers of the world, unite!'. Communism aimed to govern the entire planet, and utopian imagery to this effect abounded in the years after 1917. Tatlin's Tower was designed as a revolutionary monument to the future, for example, and not to the past. Its vast spirals were to embrace revolving committee rooms where the government of the planet would resolve its conflicts and direct its progress by radio broadcasts, and messages cast by searchlights onto clouds. The ambition of the Communist Revolution was global, and so needed global imagery; diagrams of time and space indicating man's relationships to the Cosmos. It needed, in other words, perspective systems for the age of Marxism and Relativity.

Rodchenko's constructive approach had potential for a new relationship between art and work in literally building the new society. Rodchenko realised that construction might confront, defeat, and replace composition. The elitist, exclusive aspect of art as self-expression, and as luxury goods indicative of social status, might be finally and fatally undermined. Construction was a process familiar to any builder of things, whether bridges, walls, weaving or electrical equipment. It could destroy divisions between art and work, recasting the creative visual investigator as a worker, and making work creative.

This process can be followed step by step in Rodchenko's creative development, while at the same time its emergence as theory was refined through debates at Inkhuk, where politically committed painters and theorists replaced Kandinsky. Out of their investigations emerged groups who called themselves Constructivists. When they compared the processes of composition and construction, they found decisively that *construction* was what the new society demanded.

The First Workers' Group of Constructivists gathered around Rodchenko and included some of his students. The exhibitions of the Society of Young Artists (Obmokhu) – including Ioganson, Vladimir and Georgy Stenberg, and others – exhibited assemblages of materials and geometric constructions. In among these, Rodchenko hung plywood mobile works that turned in the passing currents of air (p.54). These were made from concentric regular geometric shapes, each cut from a single sheet of plywood. The series included constructions built from concentric circles, squares, triangles, hexagons and ellipses, in which each smaller piece is turned and fixed within the next. These mobile constructions resemble the cosmological models of astrologists and astronomers. In fact in early Soviet years there were several stories of space flight in which perfect Communist societies were projected beyond planet earth. In the 1924 film *Aelita*, for example, the Revolution spreads to the planet Mars where a banner is unfurled declaring 'Workers of all planets, unite!' Bogdanov's novel *Red Star* even included a visit to the Museum of Art on Mars.

These Constructivist exhibitions had many practical, theoretical and ideological implications but they relied heavily upon Rodchenko's teaching and example.

In his black paintings Rodchenko continued to explore materials, contrasting matt surfaces with shining, glossy areas (p.21). In his study of pictorial construction in the series *Concentration of Colour and Form* of 1918, he had concentrated on circles arranged mostly symmetrically around the vertical or diagonal axis of the canvas or board (p.43). In assembling a few circular forms together he became

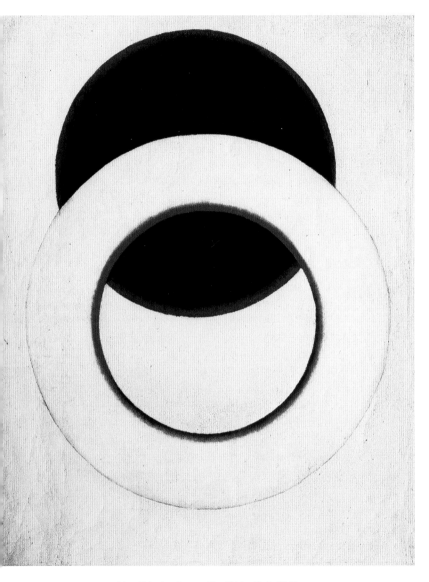

Non-Objective Composition: White Circle 1918
From the series *'Concentration of colour and form'*. Oil on canvas, 89.2 × 71.5 cm.
STATE RUSSIAN MUSEUM, ST PETERSBURG
IMAGE: BRIDGEMAN ART LIBRARY

increasingly aware that he was attacking conventions of painting. He
had become a systematic investigator with reductive, and even
destructive, intentions, and he was testing painting to breaking point.
Whether this brought him closer to a politicized art of the people is
questionable. But even within this moment of extreme austerity in his
work, something quite new and remarkable was stirring. As can be
seen from *Non-Objective Composition*, painted on board, suggestions of
figure persisted, and this was to prove significant (p.19).

In 1918-19 Rodchenko worked on collaborative projects, moving
closer to the Communist desire for work that was collective in
production, political or ideological in its message, and public in its
realisation. His museum work, teaching and theoretical debates
were already collective activities, but it now became a vital part of
his practical creative work.

One group with whom he worked in a kind of collective investigation
was called Zhivskulptarkh, an abbreviation of the Russian words for
painting, sculpture, and architecture. As the name implies, this group
combined the three activities into a new synthesis, with painters,
sculptors and architects working closely together.

For this group Tatlin's Tower provided an important example.
Designed by a painter, it had the appearance of a mechanism that
defied categorisation as a sculpture or as architecture. The models of
the Tower were built collectively by Tatlin with his students, assistants
and friends. It was decisively political in its message and exhibited at
the meeting of the Third Communist International. It was also made
public in publications and in later displays. It was designed to live in
the mind, but had it ever been built, straddling the wide river Neva in
Petrograd, and with its vast, rotating meeting halls, it would have been
a wonder of the modern world and the most public of buildings.

Something of the impact of Tatlin's project may be seen in
Rodchenko's studies with Zhivskulptarkh, although his designs for
the news and propaganda kiosks of the *Biziaks* projects of 1919 are

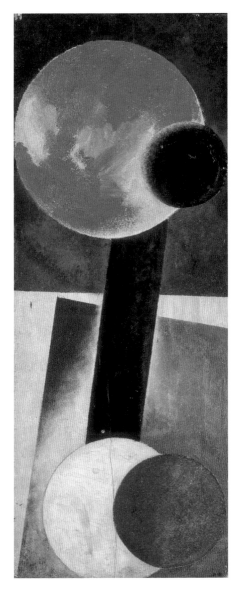

Non-Objective Composition 1918
Oil on board, 53 × 21 cm. Signed on reverse, 'Rodchenko 1918'.
STATE RUSSIAN MUSEUM, ST PETERSBURG. INV ZH-1649

much smaller in ambition and scale. Rodchenko's kiosk towers were topped by a head-like circular clock, then a torso of news screens and sign boards, and below this the box-like form of the information centre and shop. The screens and hoardings in one design declare that 'The future is our only goal', in another, 'Paris is in the hands of the Anarchists', and, in a third, fragments of the slogans 'Down with Imperialism!' and 'All Power to the Soviets!' (p.22). The critic Nikolai Punin called Tatlin's Tower the image of communal man, and Rodchenko's kiosk towers too resemble schematic, anonymous, robotic figures. One of them even has indications of legs and feet. These are also representations of collective humanity, hence their anonymity, and the message that they promote is that of early Soviet communal life. Figures like these reappear in projects over the next few years. Rodchenko made, for example, a series of designs called *Champions* that feature puppet-like competing sportsmen (p.25). These geometrically constructed figures are again anonymous and faceless with only their nationalities indicated as a sign of identity. They have the collective identity of the sports team, and they are full of vitality. Here Rodchenko has found a way of presenting figures without giving up his commitment to anonymity and collective endeavour. This was a valuable discovery on the way to finding an image of man and woman for the revolutionary new social structure. The painting *Construction on White (Robots)*, 1920, is important in this respect (p.51). It depicts both man and woman presented in poses probably derived from Albrecht Dürer's *Adam and Eve* (who were by definition ideal figures). In so far as Rodchenko's geometric figures suggest robotic anonymity in Communist society, this was an ambiguous and dangerous image to evoke. It is an interpretation to be made with care, but Rodchenko was designing costumes for exactly this theme in a proposed production of the play *We*, scripted by the Constructivist theorist and writer Alexei Gan, from the dystopian science fiction novel by Evgeny Zamyatin (pp.50-51). The play was to be directed by Sergei Eisenstein, but was never produced. The narrative of the novel describes a future where perfectly organised collective life has reduced individuality to the

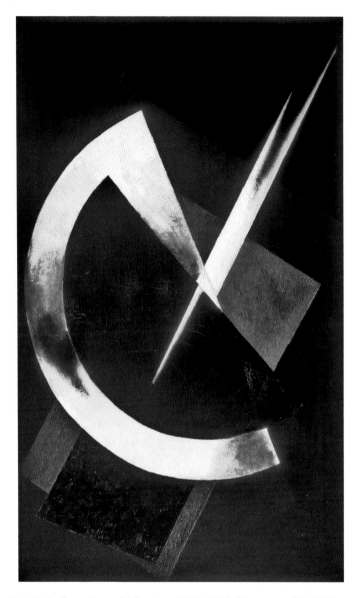

Nonobjective Composition no. 86: Density and Weight 1919. Oil on canvas, 122 × 73.5 cm.
STATE TRETYAKOV GALLERY, MOSCOW
PHOTOGRAPH: A. RODCHENKO AND V. STEPANOVA ARCHIVE, MOSCOW

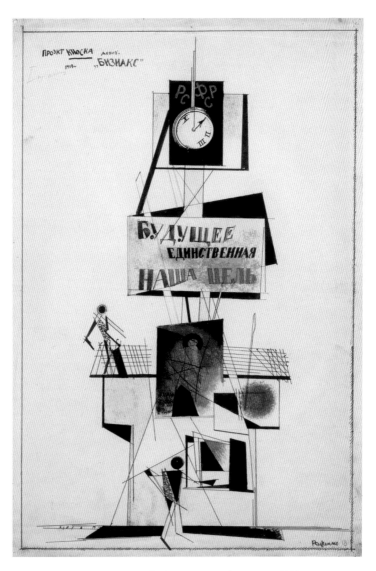

Competition design for the Biziaks news kiosk project 1919
Watercolour, pen, drawing pen and ink on paper, 51.5 x 34.5 cm.
Signed lower right in ink, 'Rodchenko'. Inscribed upper left, 'Project for the
Biziaks news kiosk 1919'. The screen declares 'The Future is our only aim'.
A. RODCHENKO AND V. STEPANOVA ARCHIVE, MOSCOW

point of disappearance. People have numbers instead of names and every moment of their life is ordered by the state into perfect harmony. Indeed, the latest aim of this society is to launch into space a craft called the 'Integral' that will bring harmony and happiness to all living creatures in the universe, whether they want it or not. Zamyatin describes a spotlessly clean nightmare world, and by implication a critique of the aims he saw emerging around him. His book was never published in Soviet Russia and Zamyatin himself had to emigrate. For Rodchenko to provide designs was provocative, but it does mean that his robotic figures may be open to alternative readings. Certainly from *Biziaks* to *We*, Rodchenko can be seen approaching a more explicit social and political dimension in his work. In painting, however, his investigation progressed more slowly, until, in 1921, it ceased. *Construction on Green no. 92* from the series *Lines*, made in 1919, uses only straight lines and two colours (p.52). A smooth monochrome provides the background for the simple constructions of lines. The effect is dynamic, suggesting movement, surfaces and even curves with few lines and without any suggestion of closed, solid form. Rodchenko has now abandoned the word *composition*, and there is no significant title. Like Zamyatin's characters, they have only numbers.

In 1920 Rodchenko made a series of paintings in black once more. *Construction no. 106* is a sparse progression of circles and lines suggesting tubes, tunnels, and planar surfaces made from crossing lines (p.27). His paintings rarely indicated any clear subject, many could be hung in any orientation, and they were mostly considered sufficient in themselves; it is not clear what the Soviet public made of them. This was largely resolved in 1921 when theoretical discussions at Inkhuk took a decisive turn. After Rodchenko and Stepanova had made their stand against the psychological approach of Kandinsky, they had embraced the construction debate. A drawing made by Rodchenko in October 1921 illustrates this moment (p.29). Here Rodchenko is studying drawing as construction; asking, in effect, how construction as a creative process can happen in drawing. Every part of this drawing connects and grows to form the larger structure, like people in an ordered society.

Debates at Inkhuk could be fundamental and fierce, and when the Constructivists took their places, Rodchenko became a key figure, along with Varvara Stepanova, Liubov Popova, and Alexander Vesnin, the painter and architect. Theorists were closely involved too: among them Nikolai Tarabukin, soon to argue against easel painting in favour of the machine, and Alexei Gan, who, in 1922, published his book *Constructivism* declaring art dead. Rodchenko too now called for unremitting war on art, asserting the political importance of Constructivism as a revolutionary force.

As it was a priority for Rodchenko and his colleagues to kill off painting, in 1921 an exhibition project was devised called 5x5=25, in which five painters each exhibited five paintings. Four of the painters were Rodchenko, Stepanova, Popova and Vesnin, all activists at Inkhuk. They were joined by Alexandra Exter, a former Russian Cubist and Suprematist, who worked in the Moscow Chamber Theatre under director Alexander Tairov. Rodchenko took centre place in the exhibition and the most principled stand. His chief exhibit, comprising monochrome red, yellow, and blue panels hung in a line, he called *Red, Yellow, Blue: The Last Painting*. The exhibition, and the debate that went with it, were to mark the end of the special status of painting within the vastly expanded territory of construction. This was their recognition of a dead end. The experimental and reductive laboratory examination of art had led to objects that were problematic both as painting and as design.

To find effective revolutionary engagement, and escape the charge of uselessness, in 1921 the Constructivists took a further fundamental step. Proclaiming their abandonment of art, they committed themselves instead to practical, useful work. Rodchenko was fully engaged in functional projects by 1923. That year, for example, he designed cine-vehicles with screens and projectors mounted upon lorries for the All-Russian Agricultural Exhibition in Moscow (p.57). For the Constructivists – including independent Constructivist Tatlin – art was transformed into design, and Constructivist methods spread as a result. Constructivist theatre found a director in Vsevolod Meyerhold, there were

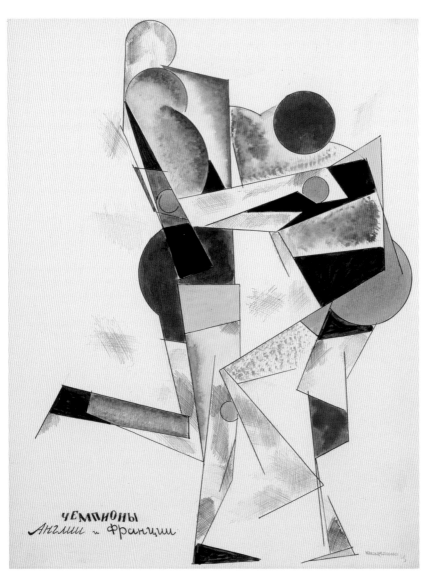

ЧЕМПИОНЫ
Англии и Франции

Champions England and France 1919. From the series '*Champions*'.
Watercolour and coloured ink, 37 × 28 cm. Signed and dated lower right,
'Rodchenko 19'. Inscribed lower left, 'Champions England and France'.
A. RODCHENKO AND V. STEPANOVA ARCHIVE, MOSCOW

Constructivist architects, and there was a Constructivist film director, Dziga Vertov. Constructivists of Rodchenko's circle moved into any kind of creative work. Rodchenko designed posters and sweet wrappers, furniture and films, stage designs, workers' clothing, fabrics, exhibition installations, and ceramics. He was especially active in typography, graphic design and in radical book design. This was a moment at which the creative lives of Rodchenko and his Constructivist circle suddenly and decisively shifted. The joint decision that arose out of experiment, experience and debate, was a collective decision, encouraged and promoted by ideologists Osip Brik, Alexei Gan, and Nikolai Tarabukin. Their views were shaped by political ideology and the Communist way of life. Luxury art goods were redundant. Without commercial galleries or private patrons art could not function as it did in Europe or America. In the eyes of the Constructivists, the new social structure meant the death of art.

The shift into design had a significance that scarcely existed outside Russia. Design in this context – whether in making a work-suit, a teapot, a building, a fabric, or a chair – was to begin the physical realisation of Communist society, its material existence coming into being. As a result, every new object from the constructivists who moved into practical design had an ideological dimension as part of the physical substance of Communist life. In architecture it led to new building types, to Workers' Clubs, and to communal kitchens and crèches in new housing blocks. Clothing had to avoid old concepts of fashion and status, while appearing fresh, wearable, warm and efficient. In Rodchenko's words, it was the creative expression of Communist culture.

Eisenstein's films could always fit into this framework and it is not surprising that Rodchenko designed posters for his films. The film director Dziga Vertov was even closer to the Constructivist position. He developed newsreel techniques in order to record Soviet daily life and show it to Soviet citizens, as he did in his film *The Man with the Movie Camera*, 1929; a film without narrative, a collage of ordinary days, made and shown to strengthen citizens' awareness of the new life emerging.

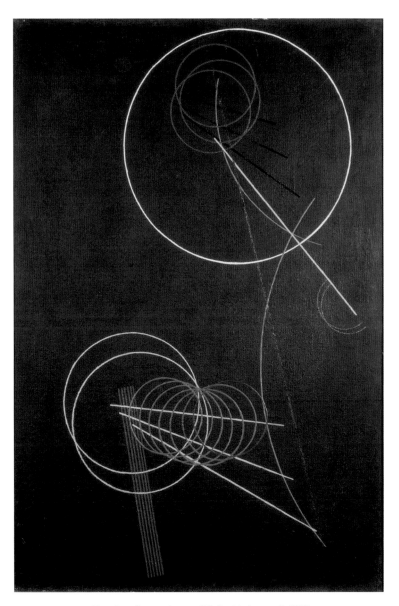

Linearism. Construction no. 106 (on black ground) 1920
Oil on canvas, 102 × 70 cm.
A. RODCHENKO AND V. STEPANOVA ARCHIVE, MOSCOW

Techniques devised by Rodchenko in his paintings now informed his designs. His posters for Vertov's *Cine-Eye* (*Kino-Glaz*) films employ his circle and line, but now add photomontage (p.56). It is all visible in Rodchenko's *Cine-Eye* poster, with its rigorous geometric structure and bold lettering. By contrast, a poetic metaphor is achieved by the photomontage as the staring human eye meets the mechanical eye of the cine-cameras. Rodchenko began to complement the ruler and compass with a camera, In his many posters, periodicals, book covers, and wrappers, his Constructivist methods were distinctive and always structural, and enriched with the photographic image. In photomontage Rodchenko found ways to complement poetic words with metaphorical photomontage images. His cover for *Kino* magazine illustrates his close connection

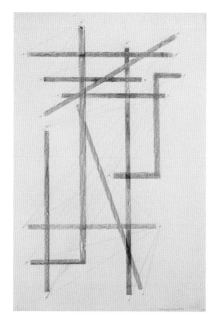

Construction drawing 1921
Coloured wax crayon on paper, 48.5 x 32.5 cm.
Signed lower right, 'Rodchenko 1921'.
LUDWIG COLLECTION, COLOGNE, INV. ML1399

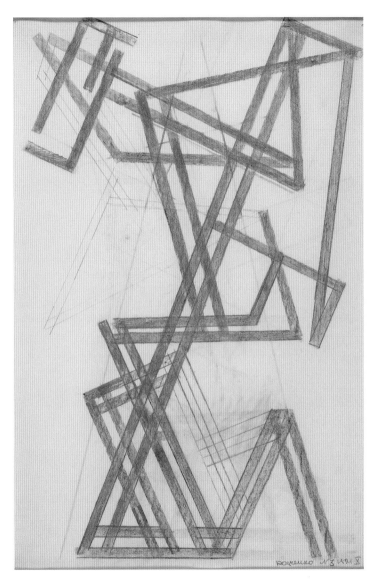

Untitled. Construction drawing October 1921
Red and blue wax crayon on paper. 48.4 x 32.3 cm. Signed and dated lower
right in ink, 'Rodchenko N3 1920 X'.

with the poet Mayakovsky, who he first met in Kazan. They
collaborated on advertisements for State stores, on wrappers for
sweets, on stage design for two Mayakovsky plays, and on the cover
and layout of *Lef* magazine.

Rodchenko's cover and illustrations for Maykovsky's book *About This*
(*Pro Eto*) use photographs of Mayakovsky and Lilia Brik, whose affair
the poem describes (p.58). The photomontages illustrate the poet's
central role, but also the images that Mayakovsky invokes in his
words. Photomontage remains the poetic dimension of Rodchenko's
graphic designs for posters, books, and periodicals. There is,
however, sometimes a reverse effect when Rodchenko simplifies a
drawing to make it a logo or trademark for particular goods or
services. Simplified aeroplanes, for example, feature in his designs
for the State airline *Dobrolet* (p.31).

These and other posters promote State enterprises. The New Economic
Policy, introduced by Lenin to boost the economy, permitted a limited
return to commercial enterprise in the Soviet Republics, and State
business had to compete. Rodchenko and Mayakovsky, operating
somewhere between advertising and propaganda, collaborated on a
whole stream of projects for State stores GUM and Mosselprom, the
Red October confectionary factory, and other political initiatives.
Rodchenko's designs flourished in this climate of competition, where
his decisive block lettering, photomontage, and symmetry stood out
among other posters and books.

A cover design for *Lef* magazine in 1924 shows his meticulous cutting
and glueing of assertive, simple, and architectonic lettering, and
intriguing, suggestive, and poetic photomontage (p.32). They indicate
well the function of Lef magazine to provide radical views, news,
politics, and poetry. Rodchenko also designed for the State publishing
house Gosizdat, including his most well-known poster *Books!* made for
its Leningrad branch (p.70). He tackled every kind of publication, from
bookmarks to detective novels, books about mass catering, posters for
cocoa, rubber galoshes, pencils, and films. And there were cheaper

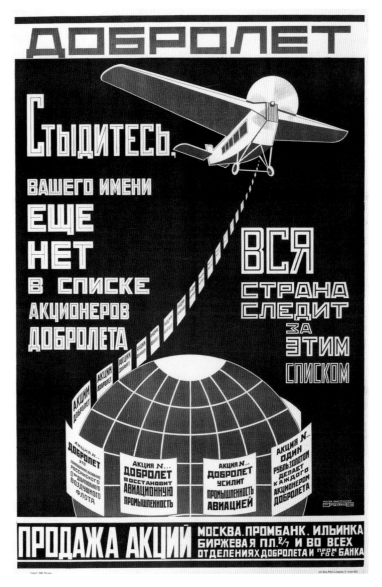

Poster for the State airline Dobrolet 1923
Lithograph, 106.5 × 71 cm.
MERRILL C. BERMAN COLLECTION, NEW YORK

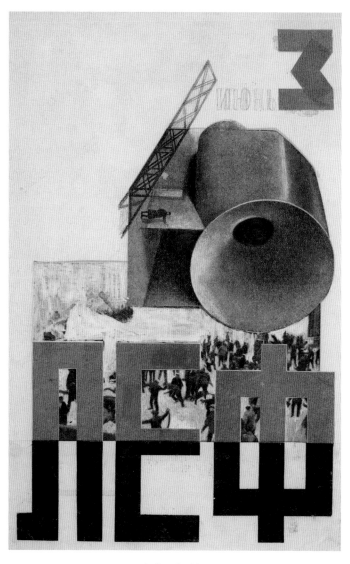

Lef, no. 3 1924
Design for the cover of *Lef* magazine.
Gelatine silver prints, printed letters cut out. Graphite pencil, gouache,
23.2 × 14.5 cm.

posters in editions of 10,000, promoting union protection, and equal pay for men and women (p.74).

His move into production led to a vast increase in range, output, and audience. In 1925 he travelled to Paris to install displays in the Soviet Pavilion and at the Grand Palais for the Paris International Exhibition of Industrial and Decorative Arts. His Workers' Club library in Konstantin Melnikov's extraordinary pavilion was heir to the intricate wooden propaganda kiosks and the only example of this type of Soviet architecture seen abroad (pp.75-76). The pavilion, painted red, grey and white, was an agitational provocation among the fine materials and elegant buildings of 1920s Paris. Rodchenko's Workers' Club was equally clear in its political role, but also welcoming and modest. This showroom for modern Soviet life was perfectly timed for Constructivist designers.

In the late 1920s Rodchenko was increasingly attracted to photography and film. He designed a whole office interior, including all the furniture, for the film *Albidium* in 1927 (p.36). In one case at least, he coloured a film-still, then signed and dated it, perhaps as an independent work, or a sign of interest in colour photography in film.

Other photographic experiments include his illustrations for Sergei Tretyakov's book *Animal Robots* (p.81). Rodchenko and Stepanova cut and slotted card to construct figures and animals, before arranging them in dramatic lighting. Then Rodchenko photographed them to illustrate the book.

In the years that followed, Rodchenko was increasingly recognised as an innovative pioneer of Soviet photography. He took photographs looking vertically down on people passing in the street, or a sports team assembling (p.82). The geometry and visual texture evident in his experimental paintings remains visible in these photographs, though it is the textures of anonymous people that now inform his work. Photography allowed him to make society itself his material

and his subject. The mechanical eye of the camera saw much more than the human eye could retain. It enabled Rodchenko to unite his human perception with that of the machine.

Only occasionally could a critical hint be found, as it was in the earlier project designs for the play We. The theatre designs that he made for Meyerhold's production of Mayakovsky's play Bedbug touched upon the same theme of what happens when a perfectly regulated society encounters raw individuality. Rodchenko, as designer of the future scenes and costumes, was bound to be associated with Mayakovsky's vision (p.84).

After the tenth anniversary of the Revolution, powerful groups of artists and critics demanded the revival of easel painting, applied to the politics of the time, and far easier for people to understand. Under Stalin the cultural environment was changing fast. Some painters, like Deineka, had learnt from Constructivists but remained figurative painters with a modern style that made political points clearly. Constructivists continued to work for the stage, and for Meyerhold in particular. Others designed State export exhibitions, as Lissitzky did. Rodchenko was criticized as too self-conscious and too artistic in his photography, qualities he had tried hard to eliminate. The photograph Dinamo Sports Club turning to enter Red Square may be seen as wilful pattern-making, or a study of anonymous figures in the collective group moving as a single creature into the political heart of Soviet culture and power (p.82).

He subsequently worked with Stepanova on overtly patriotic projects under Stalin. Official endorsement of Socialist Realism in 1932, and the dissolution of all independent groups into a single Artists' Union, ushered in a changed cultural era.

Rodchenko's photographs showed evident skill and ability within the rhetoric of political propaganda. The big photographic album volumes, including First Cavalry, offer a spectacular example of this (p.37). They are still powerful, and employ many of the techniques of

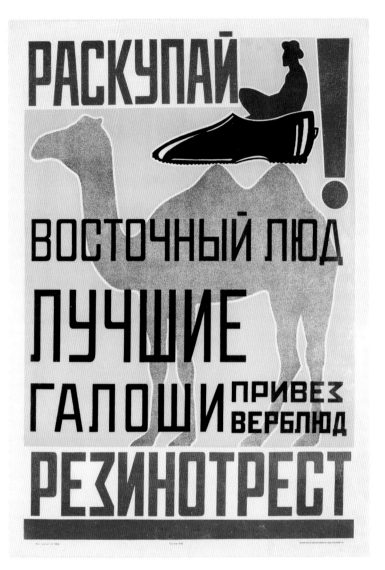

People of the East. Camels have brought you best galoshes 1923
Poster for Rezinotrest (Rubber Trust)
Lithograph on paper, 72 × 52.5 cm.
The text by Mayakovsky was also translated into Turkic.
A. RODCHENKO AND V. STEPANOVA ARCHIVE, MOSCOW

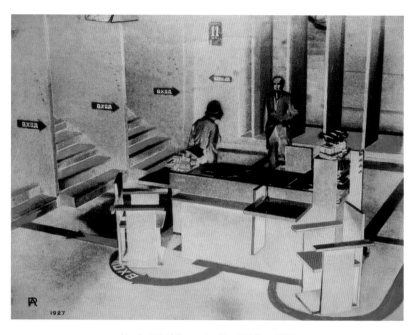

Vanderbilt's Office in the film Albidium 1927
Film still coloured by Rodchenko. The furniture is all designed by Rodchenko.
Signed and dated lower left, 'AR 1927'.
A. RODCHENKO AND V. STEPANOVA ARCHIVE, MOSCOW

constructing photographs, montages, and pages, that were first
evolved in Constructivism, but are now subject to strict political
discipline.

Privately, in his later years, Rodchenko returned to figurative
painting, especially circus themes; but there were still astonishing
moments of change and liberation, including the large painting on
paper *Expressive Rhythm* of 1943-44, made with dribbles and swirls
of paint, full of energy at every point.

For Rodchenko, design and applied art were never decoration. They
were a radical visual language, and a means to realise in some
degree the material existence of a new society.

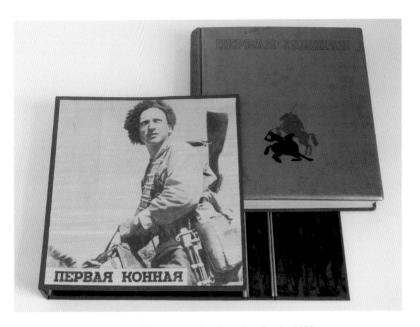

Portfolio of the photographic album First Cavalry 1938
Book. 36 x 33.5 cm.
A. RODCHENKO AND V. STEPANOVA ARCHIVE, MOSCOW

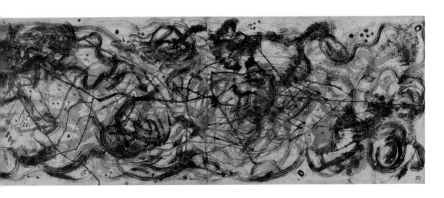

Expressive Rhythm 1943-44
Gouache, watercolour and ink on two pieces of paper overlapped,
62.4 x 172.5 cm. Signed lower right 'AR'.
NATIONAL MUSEUM OF CONTEMPORARY ART, THESSALONIKI, COSTAKIS COLLECTION, INV. 241.78/119

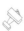

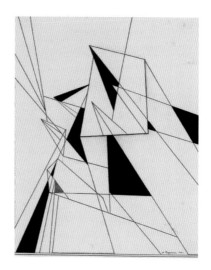

Composition (with ruler) 1915
Pen and ink on paper, 25 × 20.5 cm.
Signed and dated lower right, 'Rodchenko 15'.
A. RODCHENKO AND V. STEPANOVA ARCHIVE, MOSCOW

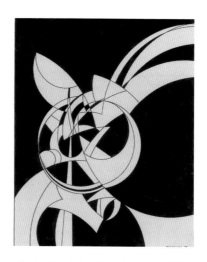

Composition (with ruler and compass) 1915
Pen and ink on paper, 25 × 20.5 cm. Signed and
dated lower right, 'Rodchenko 15'.
A. RODCHENKO AND V. STEPANOVA ARCHIVE, MOSCOW

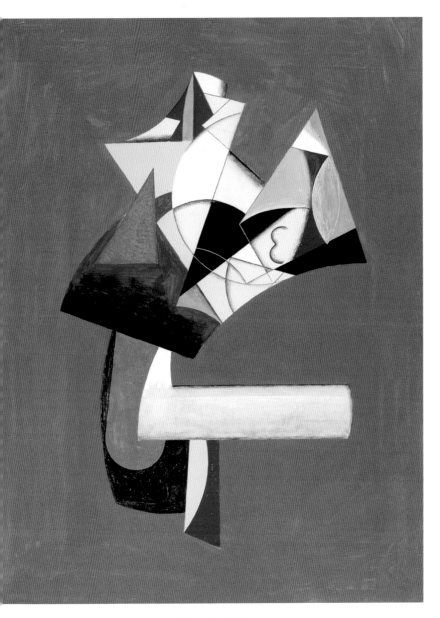

Composition 1916
A. RODCHENKO AND V. STEPANOVA ARCHIVE, MOSCOW

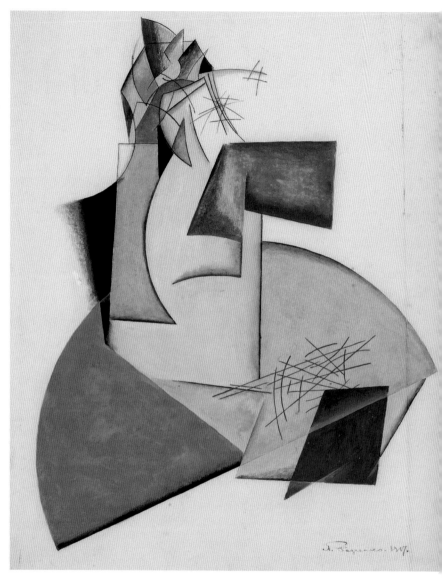

Nonrepresentational Construction of Projected and Painted Surfaces of a Complex Composition with Colours 1917. Gouache, varnish, ink on paper, 39.5 x 34.6 cm.
Signed and dated lower right, 'A. Rodchenko 1917'.
NATIONAL MUSEUM OF CONTEMPORARY ART, THESSALONIKI, COSTAKIS COLLECTION, INV. 201

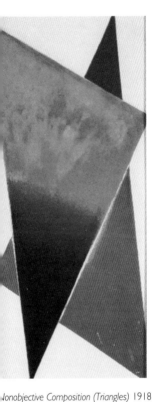

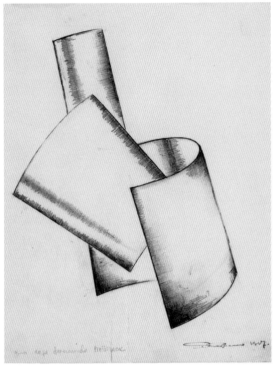

Nonobjective Composition (Triangles) 1918
Oil on wooden board, 73 × 32 cm.
Signed on reverse, 'Rodchenko 18'.
B.M. KUSTODIEV ART GALLERY, ASTRAKHAN,
INV. ZH-466

Light fixture design for Café Pittoresque, Moscow 1917
Ink on paper, 26.5 × 20.5 cm. Signed and dated lower right,
'Rodchenko 1917'. Inscribed lower left, 'For the Café Pittoresque'.
A. RODCHENKO AND V. STEPANOVA ARCHIVE, MOSCOW

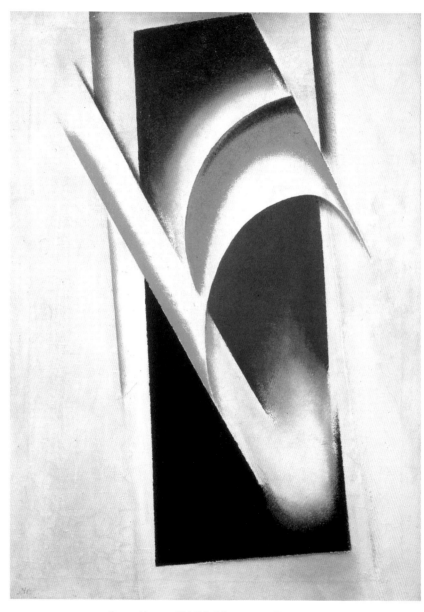

Composition, no. 56 1918. Oil on canvas, 71 × 52 cm.
A. RODCHENKO AND V. STEPANOVA ARCHIVE, MOSCOW

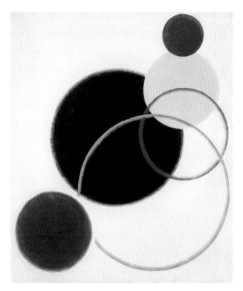

Composition 1918. From the series *'Concentration of colour and form'*. Oil on canvas.
A. Rodchenko and V. Stepanova Archive, Moscow

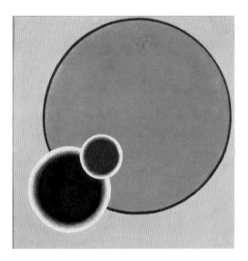

Composition no. 113 on Yellow Ground 1920. From the series *'Concentration of colour and form'*. Oil on canvas, 70.5 × 70.5 cm.
A. Rodchenko and V. Stepanova Archive, Moscow

43

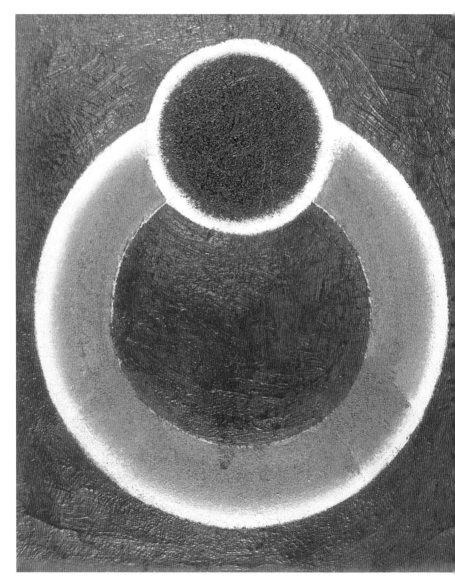

Non-Objective Composition: Two Circles 1918. From the series '*Concentration of colour and form*'. Oil on canvas, 26.7 × 22.3 cm. Stencilled in black on the reverse, 'Rodchenko 1918'.
NATIONAL MUSEUM OF CONTEMPORARY ART, THESSALONIKI, COSTAKIS COLLECTION, INV. 392

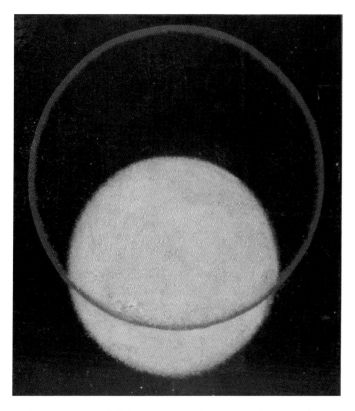

Composition no. 61 1918. From the series *'Concentration of colour and form'*.
Oil on canvas, 422 × 36 cm.
REGIONAL ART MUSEUM, TULA, INV. ZH-112

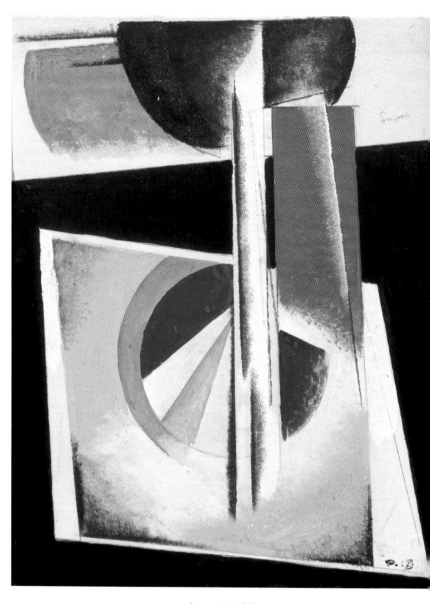

Composition 1919
Gouache on paper, 73 × 32 cm. Signed lower right, 'R 18'.
A. RODCHENKO AND V. STEPANOVA ARCHIVE, MOSCOW

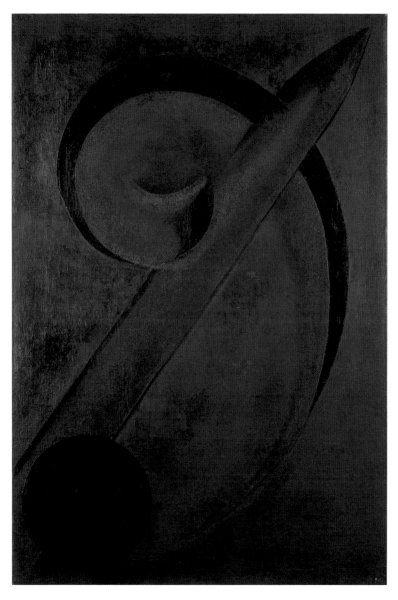

Black on Black 1918
Oil on canvas, 105 × 70.5 cm. Signed lower left, 'AR'.
LUDWIG COLLECTION, COLOGNE, INV. 1419

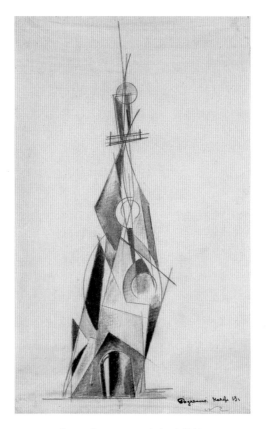

Design for a propaganda kiosk 1919
Pencil and pastel or gouache on paper, 51.5 x 34.5 cm. Signed and dated lower right, 'Rodchenko November 1919 N2'.
A. RODCHENKO AND V. STEPANOVA ARCHIVE, MOSCOW

Right: *Competition design for the Biziaks news kiosk project* 1919
Gouache and ink on paper, 47.5 x 30 cm. Signed and dated lower right in ink, 'Rodchenko 1919'. Inscribed upper left, 'Project for the Biziaks news kiosk 1919'. The screen declares, 'The Future is our only aim'. Above the clock the letters 'RSFSR' signify the Russian Federation, while the screen declares 'Down with Imp[erialism]'. Inscribed lower right, '1. Projector for announcements, 2. Hanging placards, 3. Three-sided clock, 4. Poster screen, 5. Speaker's platform, 6. Book and newspaper sales'.
A. RODCHENKO AND V. STEPANOVA ARCHIVE, MOSCOW

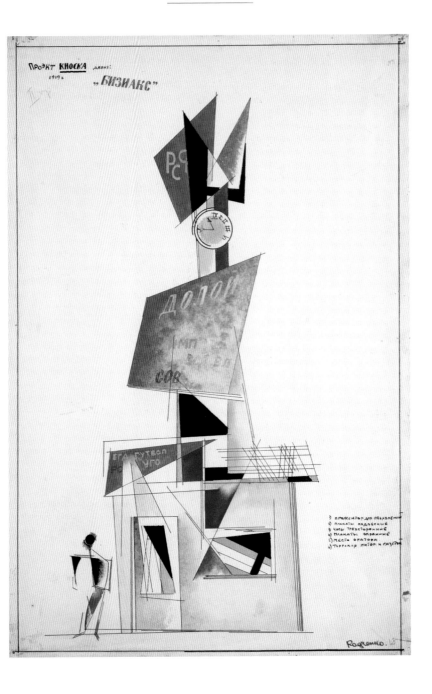

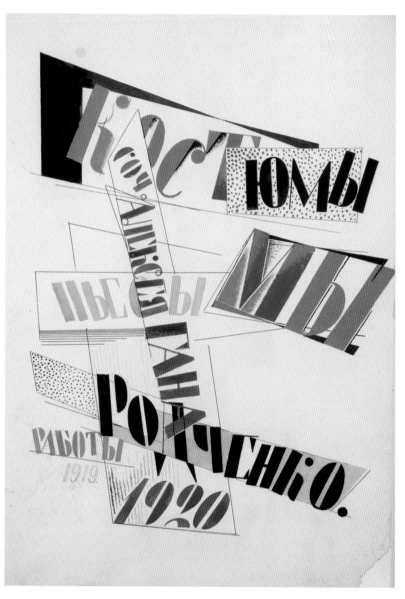

Title page for a series of costumes for Alexei Gan's play We 1919-20
Tempera, 53.2 x 36.5 cm.
A. RODCHENKO AND V. STEPANOVA ARCHIVE, MOSCOW

Clown Pierrot 1919
Costume for the play *We* by Alexei Gan.
Gouache, ink, graphite and varnish on paper,
53.2 × 37.1 cm. Signed and dated lower right,
'Rodchenko 1919'.
Inscribed lower left, 'We: Worker'.
NATIONAL MUSEUM OF CONTEMPORARY ART, THESSALONIKI,
COSTAKIS COLLECTION, INV. 50

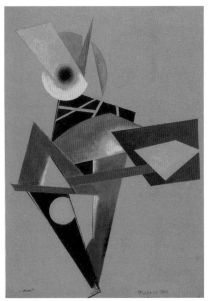

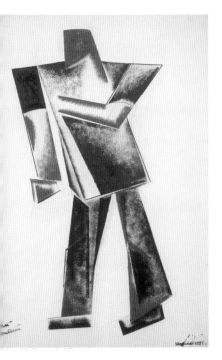

Costume for a Worker in Alexei Gan's play We 1920
Tempera and graphite pencil on cardboard,
53.2 × 36.5 cm. Signed lower right, 'Rodchenko'.
Inscribed lower left, 'We: Worker'.
A. RODCHENKO AND V. STEPANOVA ARCHIVE, MOSCOW

Construction on White (Robots) 1920
Oil on plywood, 145.8 × 95.5 cm. Stencilled
signature on reverse in black ink, 'Rodchenko' .
NATIONAL MUSEUM OF CONTEMPORARY ART, THESSALONIKI,
COSTAKIS COLLECTION, INV. 6

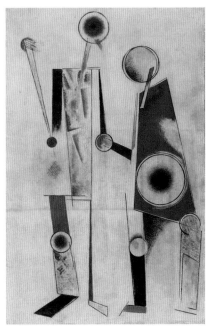

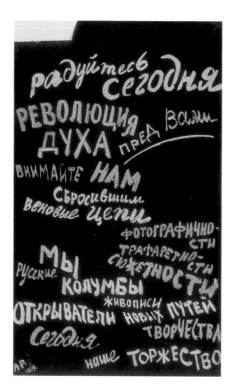

Poster design for the Tenth State Exhibition, Moscow
1919. Gouache on black paper, 52 × 32.2 cm.
Signed and dated lower left, 'A.R. 1919'.
The text reads, 'Rejoice today the revolution of
the spirit is before you. We have thrown away
the age-old chains of the photographic, banality,
subjectivity. We are the Russian doves of painting,
discoverers of the new paths of creation.'
Translation by Magdalena Dabrowski.
A. RODCHENKO AND V. STEPANOVA ARCHIVE, MOSCOW

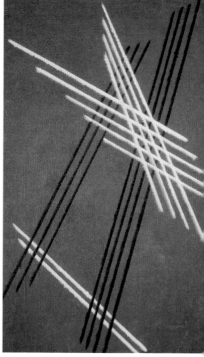

Construction on Green, no. 92 1919
From the series 'Lines'.
Oil on canvas, 73 × 46 cm.
A. RODCHENKO AND V. STEPANOVA ARCHIVE, MOSCOW

Composition no. 117 1920. Oil on canvas, 40.3 × 35.1 cm. Stencilled signature and date on the reverse, 'Rodchenko 1920 / N117'.
NATIONAL MUSEUM OF CONTEMPORARY ART, THESSALONIKI, COSTAKIS COLLECTION, INV. 288

Composition no. 120 1920. Oil on canvas, 47.5 × 35.5 cm.
A. RODCHENKO AND V. STEPANOVA ARCHIVE, MOSCOW

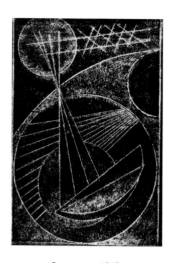

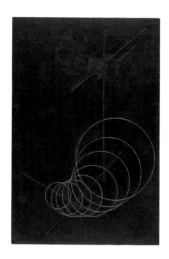

Composition 1919
One of a series of 13 prints.
Linocut on paper, 16.5 × 11.5 cm.
A. RODCHENKO AND V. STEPANOVA ARCHIVE, MOSCOW

Linearism: Construction no. 104 1920
Oil on canvas, 102.5 × 69.7 cm. Signed and dated
black paint on the reverse, 'Rodchenko / 1920 /
NATIONAL MUSEUM OF CONTEMPORARY ART, THESSALO
COSTAKIS COLLECTION, INV. 49

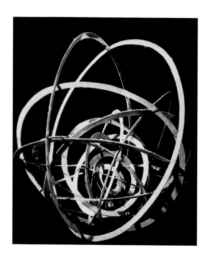

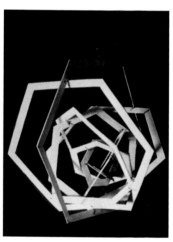

Spatial Construction no. 9: Circle 1920-21
From the series 'Planes reflecting the Light'.
Painted pear tree plywood, 90 × 80 × 85 cm.
Reconstruction model.
A. RODCHENKO AND V. STEPANOVA ARCHIVE, MOSCOW

Spatial Construction no. 10: Hexagon 1920-21
From the series 'Planes reflecting the Light'.
Painted pear tree plywood, 59 × 68 × 59 cm
Reconstruction model.
A. RODCHENKO AND V. STEPANOVA ARCHIVE, MOSCOW

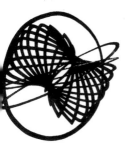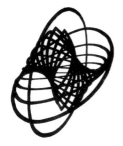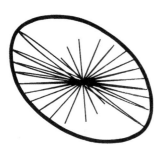

Spatial Construction no. 12: Ellipse 1920-21
Painted plywood. Profile images reflecting the development of the model in movement.
Reconstruction model by John Milner and Stephen Taylor

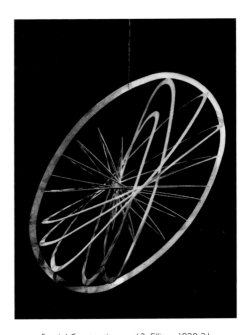

Spatial Construction no. 12: Ellipse 1920-21
From the series *'Planes reflecting the Light'*.
Painted plywood, 55 × 85 × 47 cm.
Reconstruction model.
A. RODCHENKO AND V. STEPANOVA ARCHIVE, MOSCOW

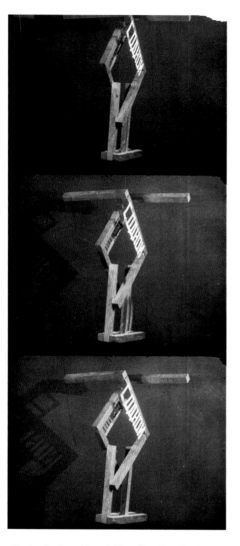

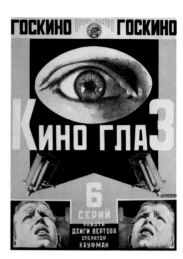

Poster for Dziga Vertov's Kino-Eye *(Cine Eye)*
1924
Poster, lithograph on paper, 92.7 x 70 cm.

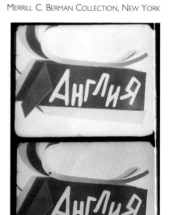

Caption for Dziga Vertov's Kino Glaz (Cine Eye) 1922
Film frames featuring incorporating Rodchenko's
Spatial Construction no. 15 of 1920-21, built in wood
on the principle of similar forms, 48 x 24.5 x 50 cm.
Published in the journal *Kino-Fot*, no. 5 1922

Caption for Dziga Vertov's Kino Pravda (Cine
Truth), no. 14 1922
Film stills: Anglia (England). Published in the
journal *Kino-Fot*, no. 5 1922

Book cover for Alexei Kruchenykh Tsotsa,
Moscow, 1921. Fastened into the book is
Kruchenykh's *Declaration of the Zaum
Language,* signed and dated 'Baku 1921'.
Collage on paper.

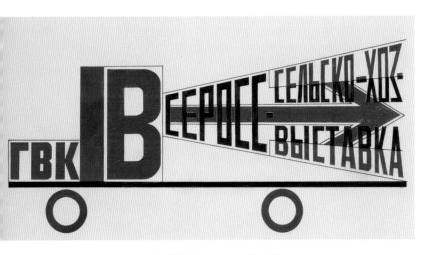

Cine vehicle 1923. Ink on paper, 36 × 26 cm.
The text reads 'Cinema vehicles at the All-Russian Agricultural Exhibition in
1923'. The screen is at the back of the vehicle.

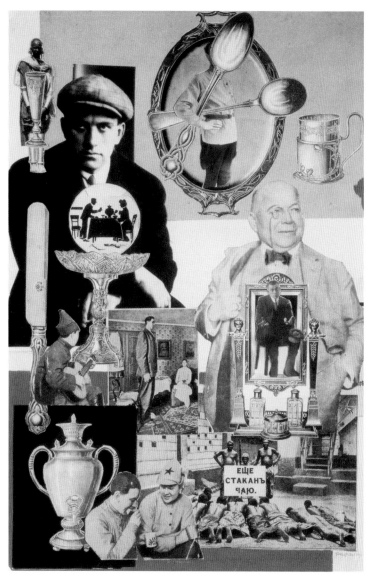

Illustration to Vladimir Mayakovsky's poem About This *1923. Collage, photomontage on paper, 47.5 × 32.5 cr*
Inscribed lower right, 'Another cup of tea'. The photomontage includes two images of Mayakovsky.
RUSSIAN STATE LIBRARY, MOSCOW
IMAGE: BRIDGEMAN ART LIBRARY

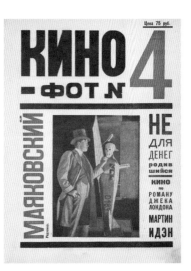

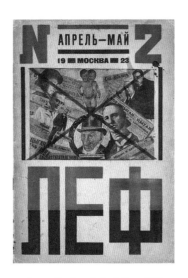

*Cover for the cinema journal Kinofot, no. 4, 1922.
Special issue devoted to the poet Mayakovsky. The
image is from Mayakovsky's film Not born for Money.*
A. RODCHENKO AND V. STEPANOVA ARCHIVE, MOSCOW

Cover of Lef no. 2, April-May, 1923
Photomontage design, 16.5 × 14.5 cm.
DAVID KING COLLECTION, LONDON

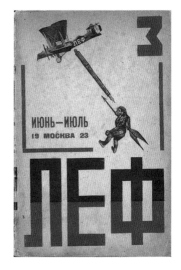

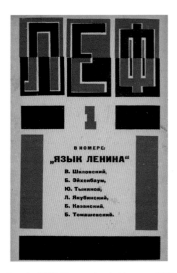

Cover of Lef, no. 3, June-July, 1923
Photomontage design, 16.5 × 14.5 cm.
DAVID KING COLLECTION, LONDON

Lef no. 1, 1924. Prospectus. Letterpress, 23.3 ×
15.5 cm. Issue devoted to Lenin's language.
MERRILL C. BERMAN COLLECTION, NEW YORK

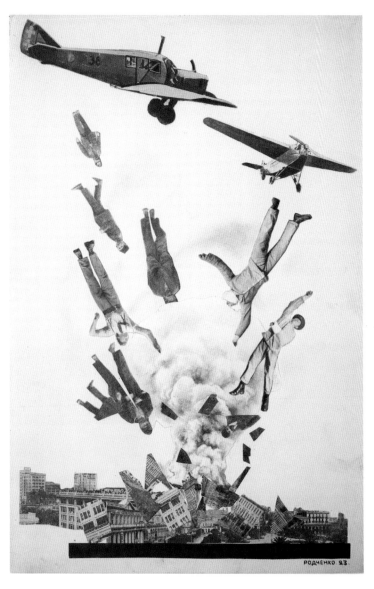

Crisis 1923. An illustration for Nikolai Aseev's book *Flight: Aero-verses*, Moscow 1923. Photomontage, black paper and graphite pencil on paper, 36.5 x 24.8 cm. Signed and dated lower right, 'Rodchenko 23'.

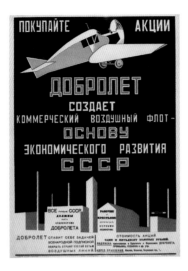

Poster for Dobrolet air services 1923
Lithograph, 70.2 × 51.5 cm.

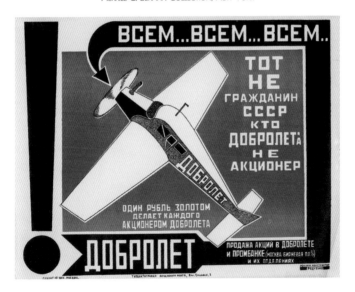

Poster for Dobrolet air services 1923
Lithograph, 36 × 45 cm.

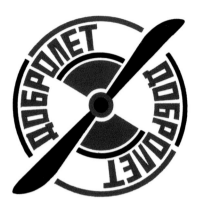

Logo for the aviation service Dobrolet 1923
Lithograph, 21 × 29.7 cm.
DAVID KING COLLECTION, LONDON

Packaging: box for Red Aviator biscuits 1925
Produced by the Red October confectionery factory, Moscow.
Lithograph on paper, 25.7 × 28.1 cm.
MERRILL C. BERMAN COLLECTION, NEW YORK

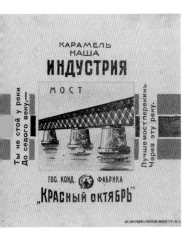

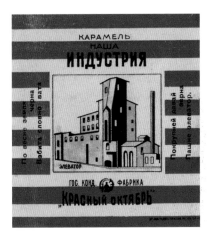

Sweet wrapper featuring a bridge 1923-24
produced for Our Industry caramels at the Red
October confectionery factory, Moscow.
Colour lithograph on paper, 8 × 7.2 cm.

Alexander Rodchenko *Box for Our Industry
caramels* 1923-24. Produced at the Red October
confectionery factory, Moscow. Colour lithograph
on paper, 34 × 23.5 cm.

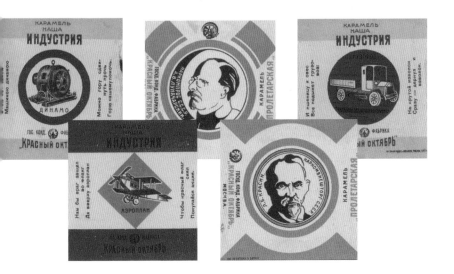

Wrappers for Our Industry and Proletarian caramels 1923-24. Produced by the Red October confectionery
factory, Moscow. Colour lithograph on paper, 8 × 7.2 cm.

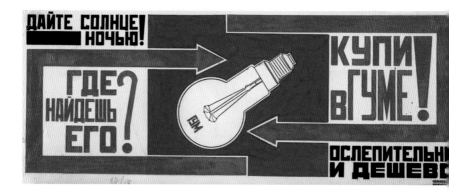

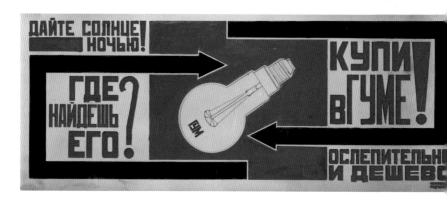

Top: *Design for a poster: 'Let there be sun at night!'* 1923
Poster advertising electric light bulbs at GUM, the State Universal Store in
Moscow. Gouache, ink, pencil on paper, 11.2 x 28.6 cm.
The text by Mayakovsky reads, 'Let there be sun at night! Where will you find
it? Buy it at GUM! Dazzling and cheap'.
A. RODCHENKO AND V. STEPANOVA ARCHIVE, MOSCOW

Bottom: *Poster: 'Let there be sun at night!'* 1923
Poster for electric light bulbs at GUM. Lithograph on paper.
MERRILL C. BERMAN COLLECTION, NEW YORK

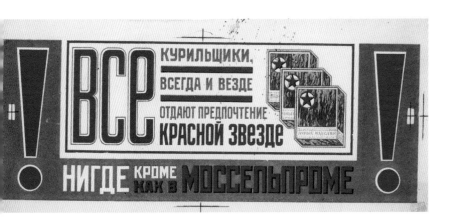

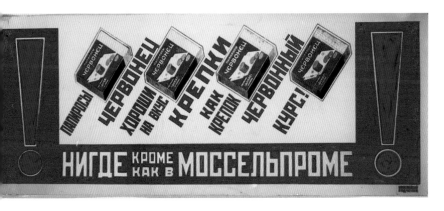

Top: *Poster for the Mosselprom Store* 1923
Poster advertising tobacco. The text reads, 'All smokers,
always and everywhere, prefer Red Star'.
Lithograph on paper, 22.7 x 44.8 cm.
Merrill C. Berman Collection, New York

Bottom: *Poster design for Chervonets cigarettes at Mosselprom* 1923
Gouache on paper, 11.1 x 27.5 cm.
Merrill C. Berman Collection, New York

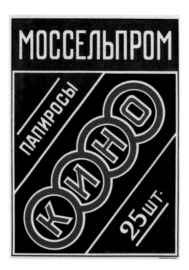

Package for Kino (Cinema) cigarettes 1924
Lithograph on paper, 32.8 x 24 cm.
MERRILL C. BERMAN COLLECTION, NEW YORK

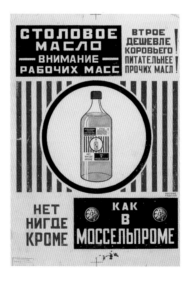

Poster for table oil at Mosselprom 1923
Lithograph on paper, 83.5 x 50.8 cm.
MERRILL C. BERMAN COLLECTION, NEW YORK

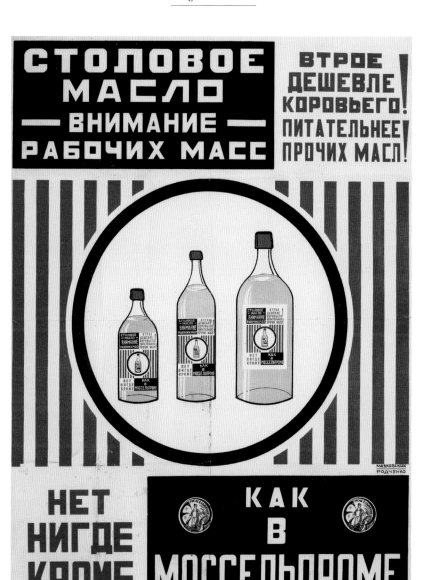

Poster for table oil at Mosselprom 1923
Lithograph on paper, 83.5 × 50.8 cm.
MERRILL C. BERMAN COLLECTION, NEW YORK

Design for a Fabric 1924
Ink and gouache on paper, 42.2 × 32.2 cm.
A. RODCHENKO AND V. STEPANOVA ARCHIVE, MOSCOW

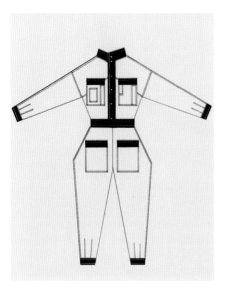

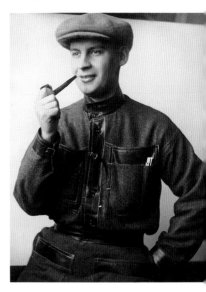

Design for a Productivist worksuit (Industrial clothing) 1923. Ink on paper, 37 × 30 cm.
A. RODCHENKO AND V. STEPANOVA ARCHIVE, MOSCOW

Rodchenko in his Productivist worksuit 1923
Photograph by Mikhail Kaufman.
A. RODCHENKO AND V. STEPANOVA ARCHIVE, MOSCOW

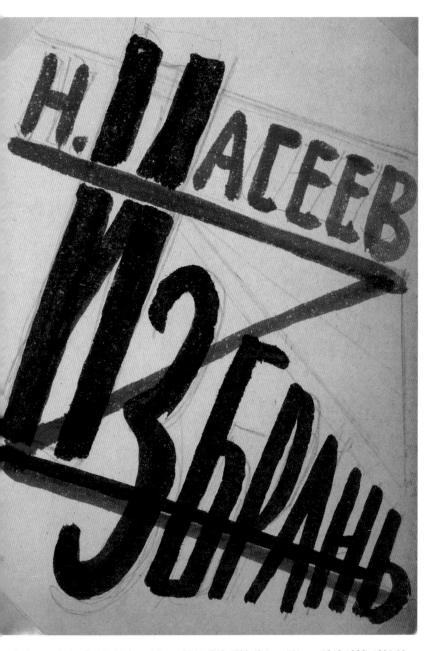

Book cover design for Nikolai Aseev Izbran, Stikhi 1912-1922 (*Selected, Verses 1912-1922*) *1922-23*
The book was published in 1923 with a different design by Rodchenko. Letterpress, 30.5 x 22.9 cm.

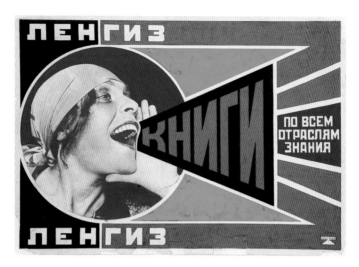

Design for a poster: 'Books for Every Branch of Knowledge' 1925
Photomontage and gouache on paper. Signed lower right above the triangle, 'Rodchenko'.
A. RODCHENKO AND V. STEPANOVA ARCHIVE, MOSCOW

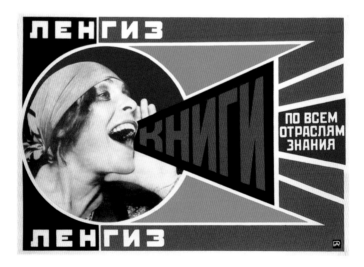

Design for a poster: 'Books for Every Branch of Knowledge' 1925
Poster for Lengiz, the Leningrad Department of Gosizdat, the State Publishing House.
Lithograph on paper, 60 × 82 cm. Signed lower right, 'AR'.
A. RODCHENKO AND V. STEPANOVA ARCHIVE, MOSCOW

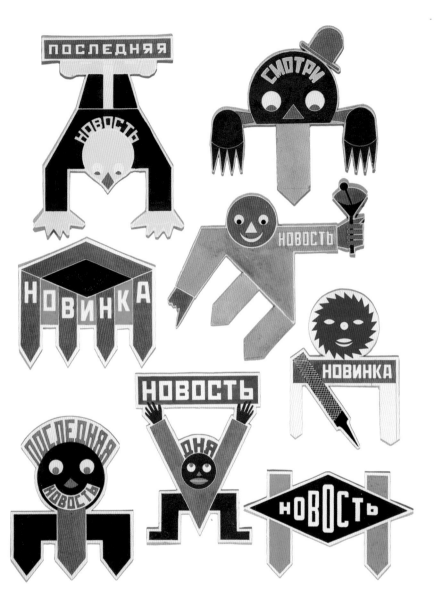

Designs for publicity bookmarks 1924
Gouache on cardboard, each one is approximately 15 × 12 cm.
A. RODCHENKO AND V. STEPANOVA ARCHIVE, MOSCOW

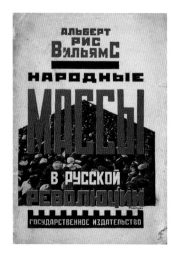

Cover for Albert Rhys Williams Masses in the
Russian Revolution: Essays on the Russian
Revolution, *Moscow / Leningrad 1925*
Printed paper, 22 × 21.5 cm.
DAVID KING COLLECTION, LONDON

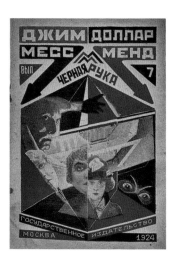

*Cover for Jim Dollar (pseudonym of Marietta
Shaginian)* Mass Mend, no. 7: Black Hand *1924*
Photomontage design, 17.8 × 12.7 cm.
DAVID KING COLLECTION, LONDON

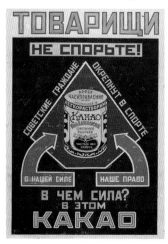

Advertisement for Cocoa 1925
Lithograph on paper, 70 × 48 cm.
MERRILL C. BERMAN COLLECTION, NEW YORK

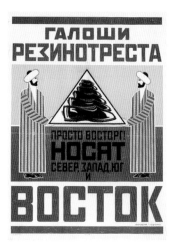

Poster for Rezinotrest Galoshes 1923
Lithograph on paper, 71 × 53 cm.
The text by Mayakovsky reads, 'Galoshes - simpl
a delight. Worn North, West, South and East'.
A. RODCHENKO AND V. STEPANOVA ARCHIVE, MOSCOW

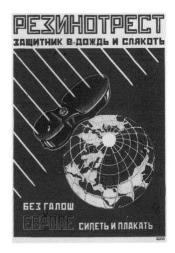

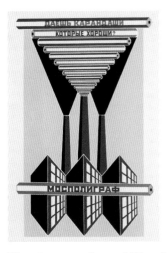

Advertisement for Rezinotrest Galoshes 1925
Lithograph on paper, 70 × 48 cm. The text reads,
'Rezinotrest defence against rain and slush'.
MERRILL C. BERMAN COLLECTION, NEW YORK

Poster: 'Where do you get perfect pencils? Mospoligraf'
1923-24. Text by Mayakovsky. Lithograph on
paper, 48 × 31 cm.
MERRILL C. BERMAN COLLECTION, NEW YORK

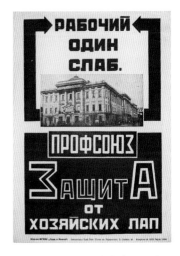

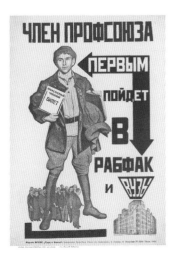

Profsoyuz poster c.1925 Lithograph.
The text reads, 'A single worker is weak'.
MERRILL C. BERMAN COLLECTION, NEW YORK

Poster promoting Trade Unions 1924
Lithograph, edition of 10,000. Text by Mayakovsky.
A. RODCHENKO AND V. STEPANOVA ARCHIVE, MOSCOW

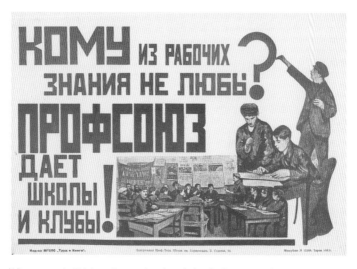

Who among the Workers does not love knowledge. Profsoyuz provides schools and clubs
c.1925. Lithograph, edition of 10,000.
A. RODCHENKO AND V. STEPANOVA ARCHIVE, MOSCOW

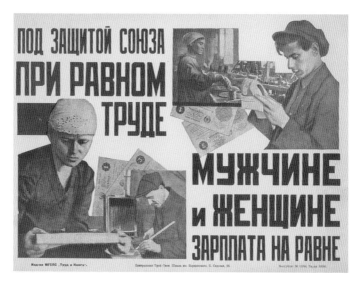

Under the protection of the Union, men and women receive equal pay for equal work
c.1925. Lithograph, edition of 10,000.
A. RODCHENKO AND V. STEPANOVA ARCHIVE, MOSCOW

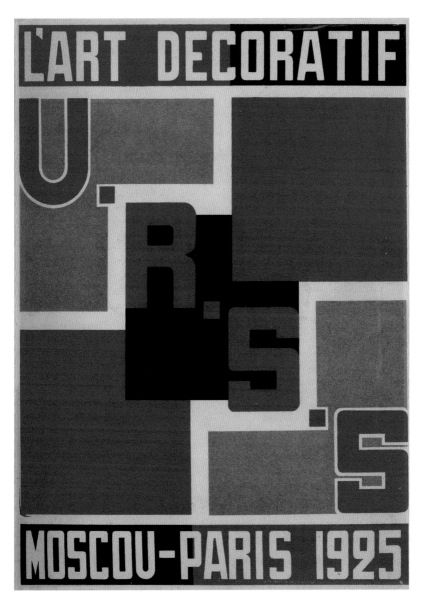

Poster for Soviet Pavilion at the Paris International Exhibition of Decorative and Industrial Arts 1925. Lithograph on paper, 26.8 × 19.9 cm.
MERRILL C. BERMAN COLLECTION, NEW YORK

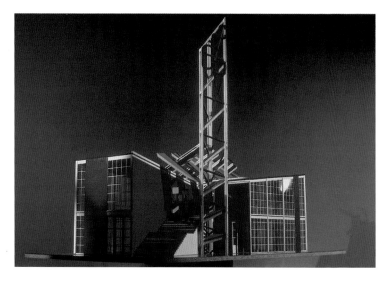

Konstantin Melnikov *Soviet Pavilion at the Paris International Exhibition* 1925
The original wood construction was destroyed. Reconstruction by Henry Milner.

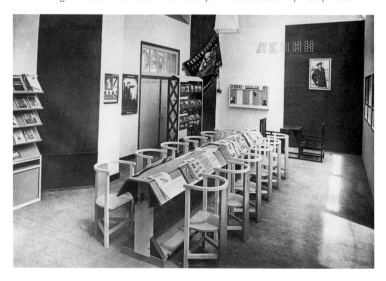

Workers' Club at the Paris International Exhibition 1925
Photograph. All of the furniture is by Rodchenko, including the hanging lamp and the
chess table visible beneath the painting of Lenin.
A. RODCHENKO AND V. STEPANOVA ARCHIVE, MOSCOW

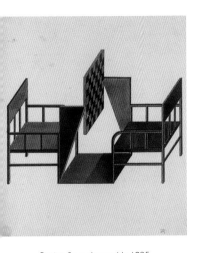

Design for a chess table 1925
The chess table was exhibited in Rodchenko's
Workers' Club at the Paris International
Exhibition. Black and red india ink, and gouache
on paper, 36.5 × 25.5 cm.
A. RODCHENKO AND V. STEPANOVA ARCHIVE, MOSCOW

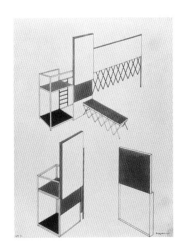

*Designs for furniture at the Paris International
Exhibition* 1925
Ink and gouache on paper, 36.1 × 25.4 cm.
A. RODCHENKO AND V. STEPANOVA ARCHIVE, MOSCOW

*Designs for display stands at the Paris International
Exhibition* 1925
Ink and gouache on paper, 36.1 × 25.4 cm.
A. RODCHENKO AND V. STEPANOVA ARCHIVE, MOSCOW

*Designs for the entrance to the Workers' Club, Paris
International Exhibition* 1925
Gouache on paper, ink and gouache on paper,
36.1 × 25.4 cm.
A. RODCHENKO AND V. STEPANOVA ARCHIVE, MOSCOW

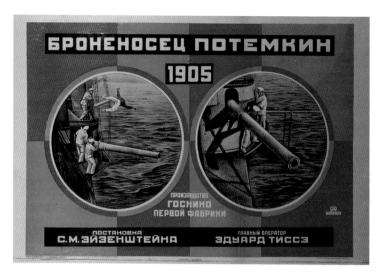

Poster for Sergei Eisenstein's film Battleship Potemkin 1925 Lithograph on paper, horizontal format featuring two circles, 71.7 × 107.9 cm. Signed lower right, 'AR'.
MERRILL C. BERMAN COLLECTION, NEW YORK

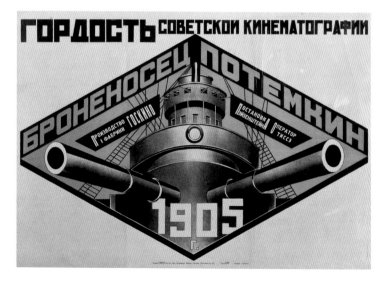

Poster for Sergei Eisenstein's film Battleship Potemkin 1925
Lithograph on paper, horizontal format, 70 × 98.5 cm.
MERRILL C. BERMAN COLLECTION, NEW YORK

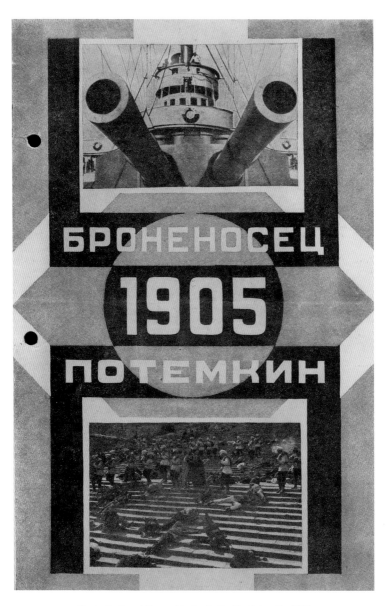

Poster for Sergei Eisenstein's film Battleship Potemkin 1925
Lithograph on paper, vertical format, 98.5 × 70 cm.
MERRILL C. BERMAN COLLECTION, NEW YORK

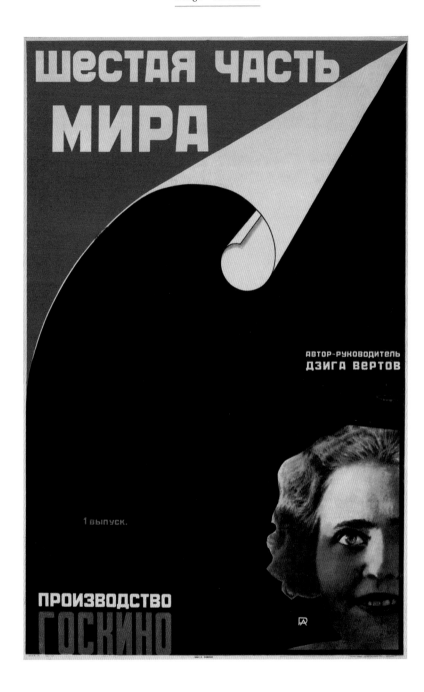

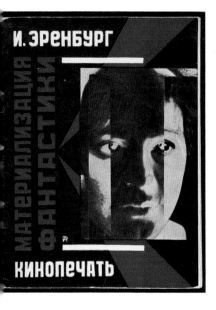

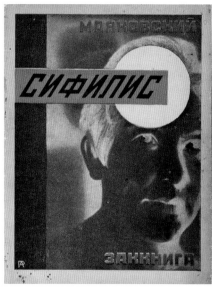

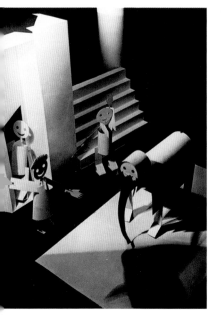

Top left: *Cover for Ilya Ehrenburg* Materialization of the Fantastic 1927. Printed book. Letterpress on paper, 17.5 × 13.2 cm.
<small>BRITISH LIBRARY, LONDON</small>

Top right: *Book cover for Vladimir Mayakovsky* Syphilis 1927. Printed book. Letterpress on paper. 15.8 × 12 cm
<small>BRITISH LIBRARY, LONDON</small>

Left: *Photographic illustrations for Sergei Tretyakov* Robot Animals 1926. Photograph, 39.5 × 29.5 cm.
<small>LUDWIG COLLECTION, COLOGNE, INV. ML/F 1978/1026</small>

Opposite page: *Poster for Dziga Vertov's film* Sixth of the World 1926. Lithograph, 105 × 68.8 cm.
<small>MERRILL C. BERMAN COLLECTION, NEW YORK</small>

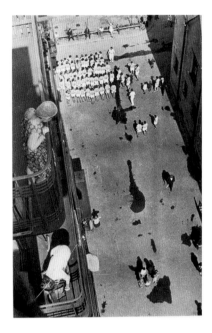

Left: *Gathering for a demonstration* 1928
Photograph, 40 × 27 cm.
A. RODCHENKO AND V. STEPANOVA ARCHIVE, MOSCOW

Below: *Street* 1927-28
Photograph.
A. RODCHENKO AND V. STEPANOVA ARCHIVE, MOSCOW

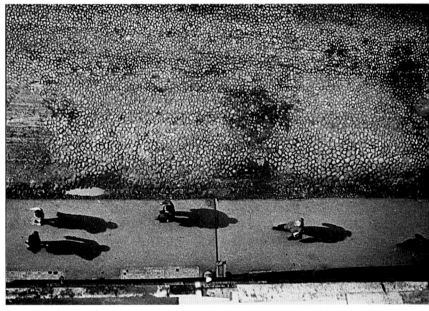

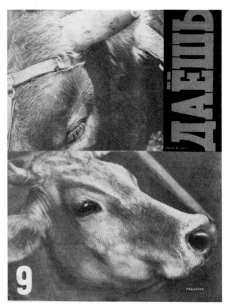

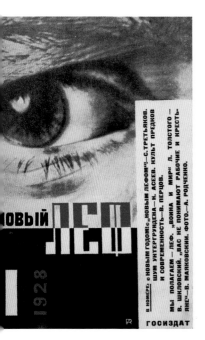

ɔver for the journal Novyy Lef (New Left) no. 1,
1928. Letterpress on paper, 22.5 ×15 cm.
MERRILL C. BERMAN COLLECTION, NEW YORK

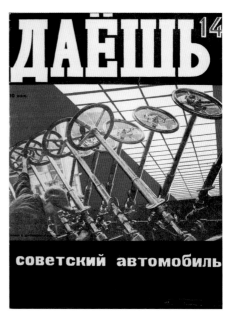

Top right: *Dayosh (Forward), no. 9, 1929*
Periodical cover featuring cattle.
Letterpress, 30.5 × 22.7 cm.
MERRILL C. BERMAN COLLECTION, NEW YORK

tom right: *Dayosh (Forward): Soviet Motorcars, no. 14*
)29. Periodical cover. Letterpress, 30.5 × 22.7 cm.
MERRILL C. BERMAN COLLECTION, NEW YORK

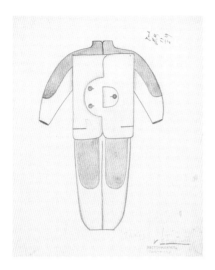

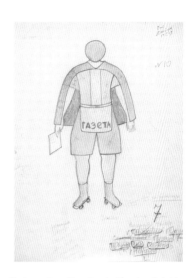

Costume for The Manager in Mayakovsky's play
Bedbug 1929. Pencil and coloured crayon on
paper, 36 × 27 cm.
A. RODCHENKO AND V. STEPANOVA ARCHIVE, MOSCOW

Costume for a Newsboy in Mayakovsky's play
Bedbug 1929
Pencil and coloured crayon on paper, 36 × 27 c
A. RODCHENKO AND V. STEPANOVA ARCHIVE, MOSCOW

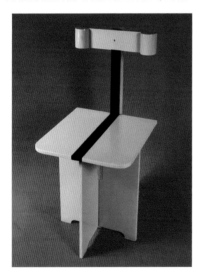

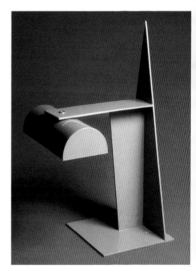

Folding chair for Anatoly Glebov's play Inga 1929
Reconstruction.
A. RODCHENKO AND V. STEPANOVA ARCHIVE, MOSCOW

Table lamp for Anatoly Glebov's play Inga 1929
Reconstruction.
A. RODCHENKO AND V. STEPANOVA ARCHIVE, MOSCOW

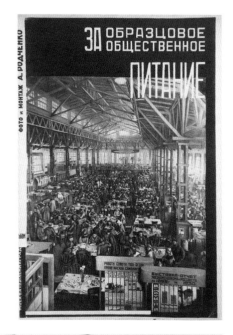

Cover of the publication Exemplary
Public Catering c.1931
Letterpress. Illustrated with photographs
and photomontages by Rodchenko.
A. RODCHENKO AND V. STEPANOVA ARCHIVE, MOSCOW

Photomontage illustrations: Exemplary
Public Catering
Letterpress. Illustrated with photographs
and photomontages by Rodchenko.
A. RODCHENKO AND V. STEPANOVA ARCHIVE, MOSCOW

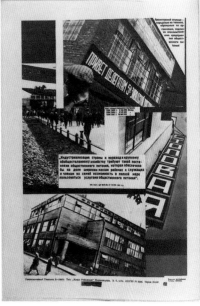

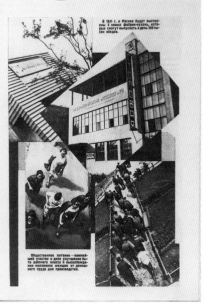

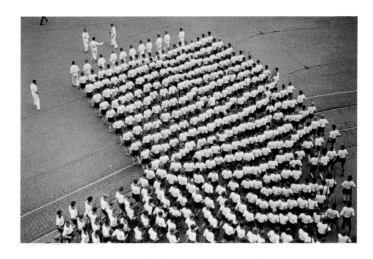

Column of the Dinamo Sports Society 1932
A column of athletes entering Red Square.
Photograph, 49.2 × 59 cm.
A. RODCHENKO AND V. STEPANOVA ARCHIVE, MOSCOW

Portrait of Rodchenko 1938
Photograph.
A. RODCHENKO AND V. STEPANOVA ARCHIVE, MOSCOW

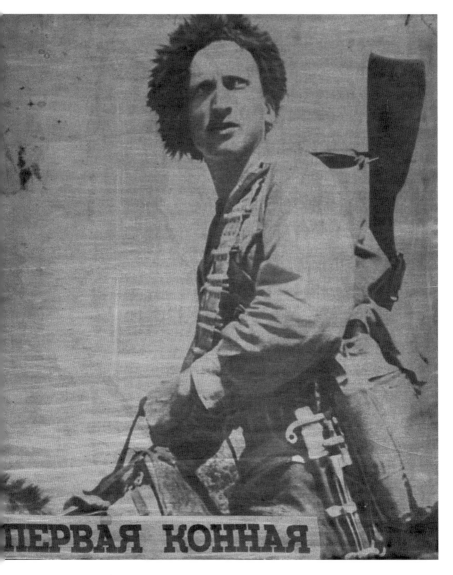

ПЕРВАЯ КОННАЯ

Alexander Rodchenko with Varvara Stepanova *Portfolio of the photographic album* First Cavalry 1938. Book cover, 36 x 33.5 cm.

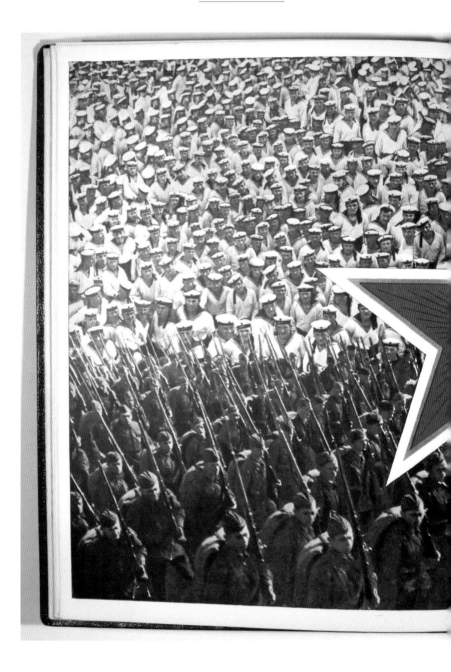

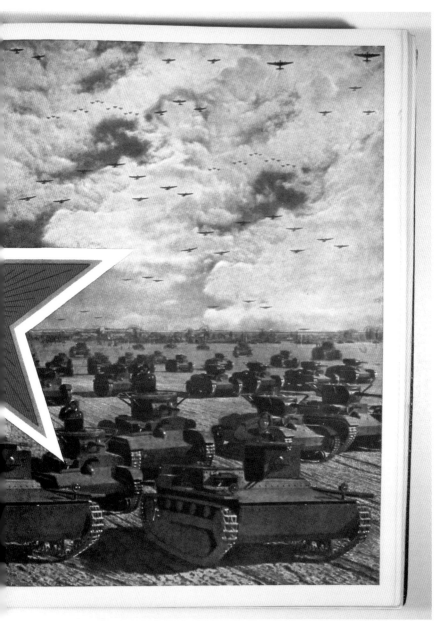

Alexander Rodchenko with Varvara Stepanova *Double page spread in a photographic album celebrating the Soviet armed forces* 1938
A. RODCHENKO AND V. STEPANOVA ARCHIVE, MOSCOW

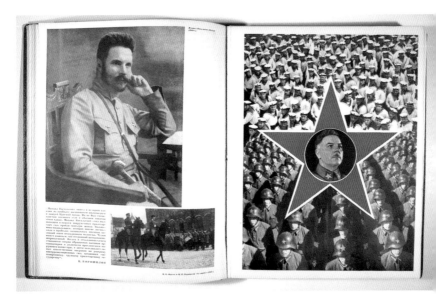

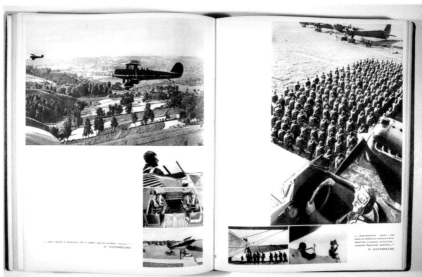

Alexander Rodchenko with Varvara Stepanova *Double page spreads in a photographic album celebrating the Soviet armed forces 1938*
A. RODCHENKO AND V. STEPANOVA ARCHIVE, MOSCOW

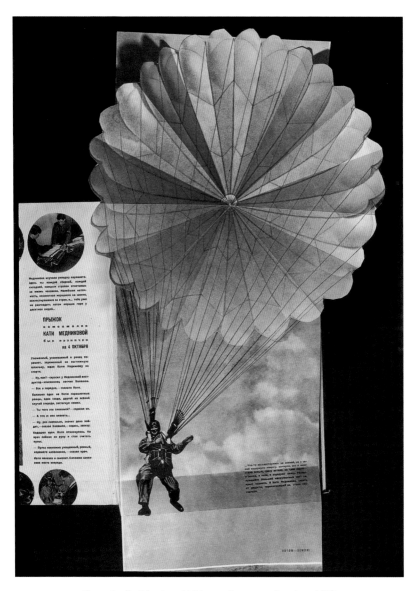

Alexander Rodchenko with Varvara Stepanova *Parachute* 1935
Fold out parachute illustration for *USSR in Construction* (SSSR na Stroike) no. 12,
1935
Gravure, 85.1 × 68.6 cm.
DAVID KING COLLECTION, LONDON

Circus 1940
Photograph, 25.4 × 35.3 cm.
DAVID KING COLLECTION, LONDON

Rhine Wheel Act 1940
Photograph, 25.4 × 35.3 cm.
DAVID KING COLLECTION, LONDON

Georgiy Petrusov *Caricature of Alexander Rodchenko* 1933-34
Photograph, double exposure, 29.3 x 40 cm.
A. RODCHENKO AND V. STEPANOVA ARCHIVE, MOSCOW

Alexander Mikhailovich RODCHENKO

1891 Born in St Petersburg, Russia.

1910 Entered Kazan School of Art.

1914 Met Varvara Stepanova, his lifelong partner and colleague, at Kazan Art School.

1914 Attended Russian Futurists' event at Kazan.

1915 Enters Graphics course at the Stroganov School of Applied Arts, Moscow.

1916 Showed work with Tatlin, Malevich, and others at Tatlin's exhibition *The Store*.

1917 Became a founder member of Professional Society of Artists, leftist section. Decorated Café Pittoresque, Moscow, with Tatlin and Yakulov.

1918 Involved in restructuring of art under the Soviets, including Art and Production, the Museum Bureau, and the Fifth State Exhibition.

1919 Exhibited at the Tenth State Exhibition: Non-Objective Art and Suprematism. Taught at Free State Studios.

1920 Exhibited at Congress of Third Communist International. Exhibited at the Nineteenth State Exhibition. Taught at Vkhutemas.

1921 Active in debates at the Institute of Artistic Culture, Moscow. Exhibited *The Last Painting* at the Moscow exhibition 5 x 5 = 25. Renounces art for useful production.

1922 Exhibited at the *First Russian Art Exhibition*, Van Diemen Gallery, Berlin.

1923 Collaboration with poet Vladimir Mayakovsky on advertisements for State stores, book design for the State publishing house, and political posters. Designed covers for *Lef* magazine, using photomontage with typography.

1925 Designed posters for films including Sergei Eisenstein's *Battleship Potemkin*. Travelled to the Paris International Exhibition of Industrial and Decorative Arts. Installed *Worker's Club* at Paris Exhibition, designed its posters and furniture.

1926 Editorial work on Soviet magazine *Contemporary Architecture*. Increasing involvement in photographic work.

1927 Design for films, including interiors and furniture.

1935 Worked on design of periodical *USSR in Construction*. With Stepanova designed photographic albums *First Cavalry* and *Soviet Cinema*.

1938 With Stepanova designed photographic album *Red Army*.

1942 Married Stepanova.

1956 Died in Moscow.

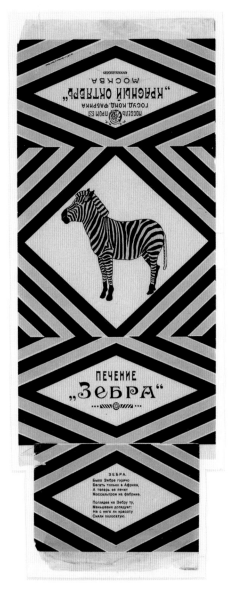

Packaging for *Zebra biscuits* 1923-24
Produced by the Red October Factory. Lithograph on paper. 48 x 31 cm.
MERRILL C. BERMAN COLLECTION, NEW YORK

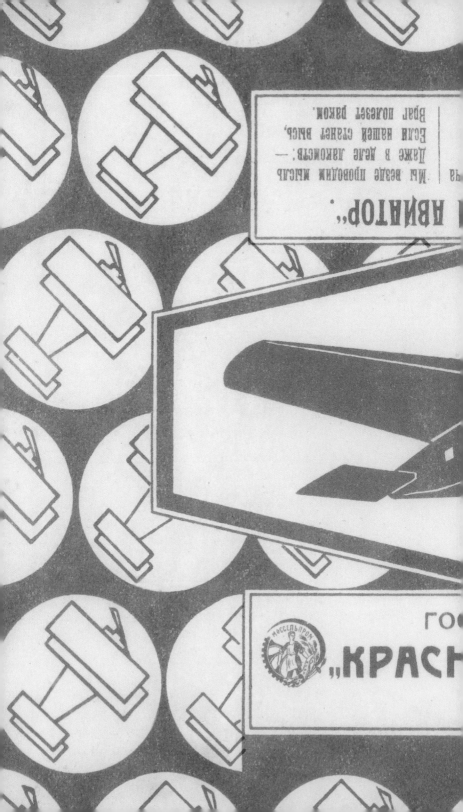